AROUND DURHAM

THROUGH TIME

Michael Richardson

AMBERLEY

Acknowledgements

So many people have donated and loaned photographs to the Gilesgate Archive that it is impossible to thank them all. Special thanks go to the following: Mr Dave Arnott, Mrs Jean Blackburn, Mr Chris Carman, Mrs Betty Dodd, Mr Bill Errington, Mr Ian Forsyth, Mrs Margaret Hedley, the late Mr Ken Hoole, Mr Peter Killian, Mr Ray Kitching, Mr George Nairn, Miss Dorothy R. Meade, Mr R Mechen, Mr J. A. Peden, Mrs Norma Richardson, the late Mr Joe Robinson, Durham Record Office, Palace Green Library, The Armstrong Trust and Clayport Library.

If any readers have new material, photographs, postcards, slides, negatives or information they should contact:

Gilesgate Archive,
C/o Michael Richardson,
128 Gilesgate,
Durham,
DH1 1QG

Email: gilesgatearchive@aol.com
Telephone: 0191 3841427

First published 2010

Amberley Publishing Plc
Cirencester Road, Chalford,
Stroud, Gloucestershire, GL6 8PE

www.amberley-books.com

Copyright © Michael Richardson, 2010

The right of Michael Richardson to be identified as the Author of this work has been asserted in accordance with the Copyrights, Designs and Patents Act 1988.

ISBN 978 1 84868 557 4

British Library Cataloguing in Publication Data.
A catalogue record for this book is available from the British Library.

Typeset in 9.5pt on 12pt Celeste.
Typesetting by Amberley Publishing.
Printed in the UK.

Introduction

Around Durham Through Time consists of 180 photographs (sepia and colour) with informative text relating to the villages lying to the east, within the present city boundary. Those listed are: Carrville, Belmont, West Rainton, Leamside, Low and High Pittington, Littletown, Sherburn Hill, Shadforth, Ludworth, Sherburn Village, Sherburn House, High Shincliffe, Shincliffe, Houghall and Old Durham. Although some have an ancient history, most developed with the sinking of coal-mines. Much of the area has been transformed from the days when the villages consisted of long dreary colliery-rows and pit-heaps.

The inclusion of recent (late October 2009) colour photographs show how places have either altered or remained the same. Where possible I have taken the recent image from the same viewpoint and made a note of the photographer. For example, Billy Longstaff, an ex-miner and model engineer from Sherburn Village, whose pictures of Sherburn Hill and Sherburn in the 1950s and early 1960s have left us a remarkable record of scenes long since gone. Many were taken in colour, which was then not so popular due to it being more expensive to buy and develop.

After perusing these pages you may look upon the villages in a different light. It has given me great pleasure to re-visit some of my favourite haunts, such as Leamside, St Lawrence's church at Pittington, Sherburn Hospital and Old Durham. It is hoped that the next volume will cover the other villages around the city, like Quarrington Hill, Coxhoe, Croxdale, Brancepeth, Esh Winning and Ushaw Moor. I have enjoyed speaking to many interesting people while out taking the new images for this book. I believe this volume will give you, the reader, as much interest as it has given me in putting it together.

Michael Richardson
Gilesgate Archive
2010

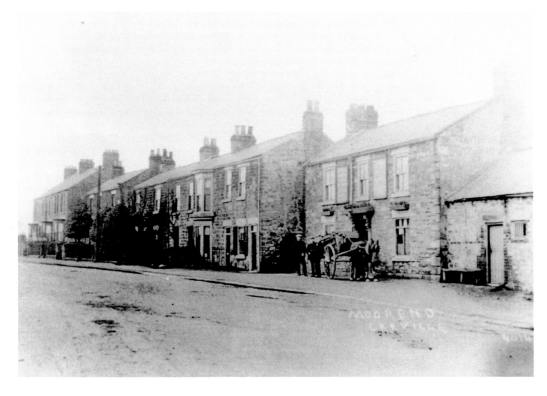

Moor End, Carrville
Looking towards Durham from the junction near St Mary Magdalene's church, 1900s. On the right is the Sportsman's Arms public house. The name, Moor End, comes from the fact that this area was at the end of the moor, which covered an area of 235 acres and was enclosed in 1817.

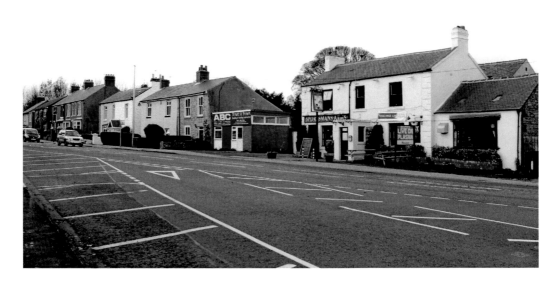

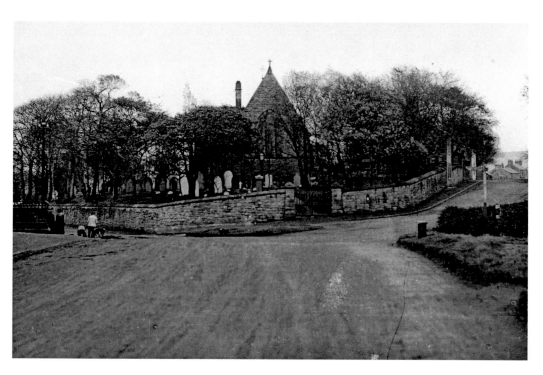

Belmont Church, c. 1905
The road on the left leads to Carrville and the one on the right to Broomside Lane. The old school, which was first opened in 1838 (prior to the church being built), can be seen on the right of the church, almost hidden behind the trees. This area is now part of the churchyard.

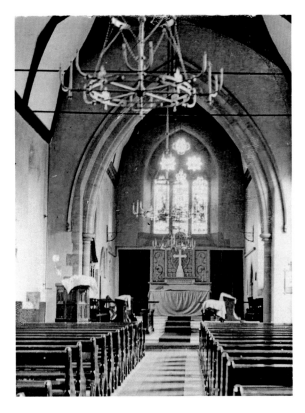

The Interior of St Mary Magdalene's Church, Belmont, c. 1905
The church was consecrated 15 October 1857 and was designed by William Butterfield. Minor alterations were made in 1872, the north porch was added in 1889 and a new choir vestry in 1901. Note the three old gas chandeliers. In 1925, electric lighting was installed.

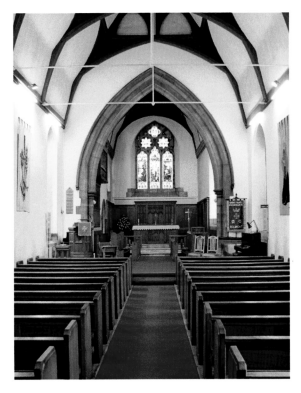

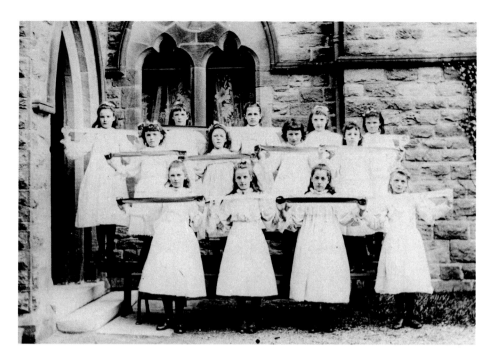

A Dance Group with Ribbons Outside Belmont Vicarage, 1890s
The porch, on the left, was removed in the 1960s during the time of the Revd. C. J. W. King. The building was designed by Walton and Robson of Durham and London and was built about 1861-63. It is now a nursing and residential home called Belmont Grange. An interesting point regarding the site is that the coal seam, underneath the vicarage, was worked out by Sherburn Colliery. Stone was 'put in place' to support the building (details from a letter by Thomas Elliot of West Sherburn to the parsonage, dated 15 June 1868, held in Durham Record Office).

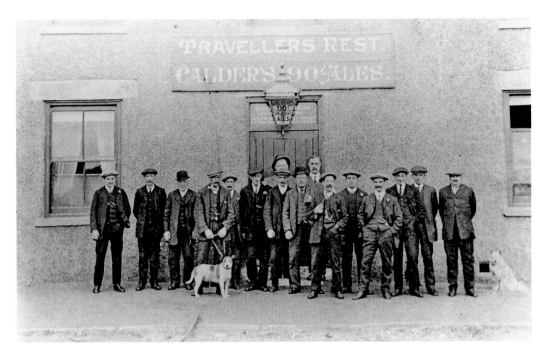

Customers Outside the Old Travellers' Rest, Broomside Lane, *c.* 1910

The landlord, Robert Bowman, is pictured without a hat to the right of the door. The site of the old Travellers' Rest is now occupied by two new houses. The present public house, which bears the same name, was built nearby in the 1960s.

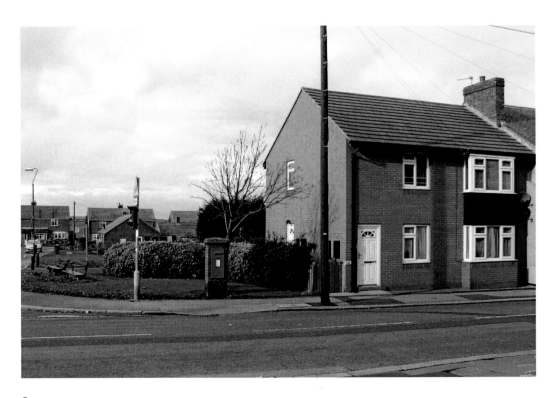

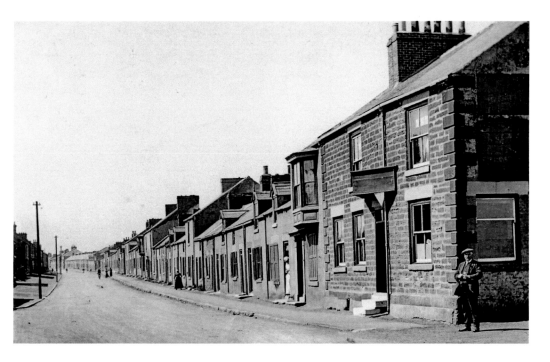

The Colliery Row

The long colliery row of Carrville High Street from the bottom end, *c.* 1920, taken by G. Dunn, South Street, West Rainton. Many of the attic rooms of these houses were later heightened to make extra space. The present pebble-dashed and rendered fronts hide this alteration (only number 43 survives unaltered). On the right is the King's Arms Inn. The road at the end of the gable led to the Grange Iron Works.

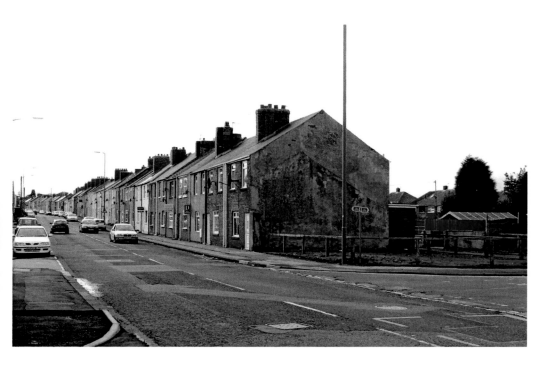

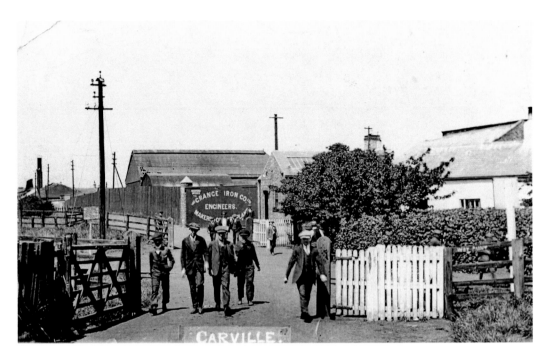

The Grange Iron Works, Carrville, Early 1920s, taken by G. Dunn

The company once had a large export business trading to all parts of the globe. Its end came about on 29 August 1925, when it went into liquidation. The workforce was transferred to Joseph Cook and Sons, Washington, *c.* 1926. The Grange Caravan Park now occupies part of the iron works site.

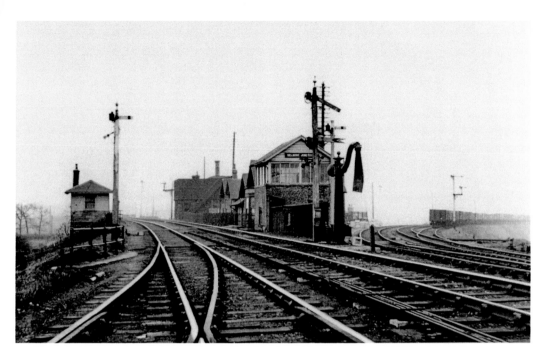

Belmont Junction, Carrville, 1950s
On the right is the railway-line branching off towards Gilesgate Goods Station (note the coal-trucks). The line closed in 1966 and is now the route of the A690 road into Durham City. Behind the signal box is the former Belmont Station. The water crane on the right was used for re-filling the tanks of the steam railway engines.

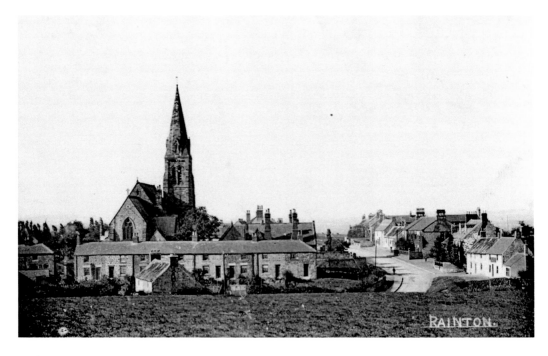

St Mary's Church, West Rainton

With its landmark spire (138 feet high), St Mary's church is viewed here from the east of the village, *c.* 1910. The row of stone cottages, Church Street, on the left, still exists. The whitewashed building on the extreme right was a public house called the Lord Seaham. The open field, from where the photograph was taken, is now occupied by new housing named The Meadows.

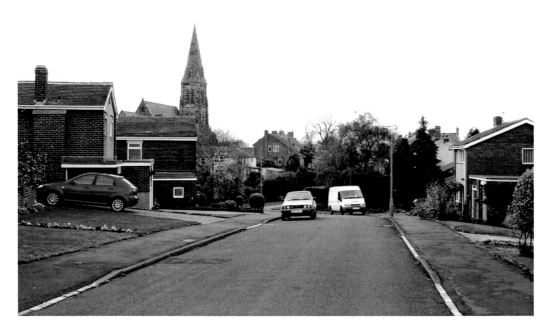

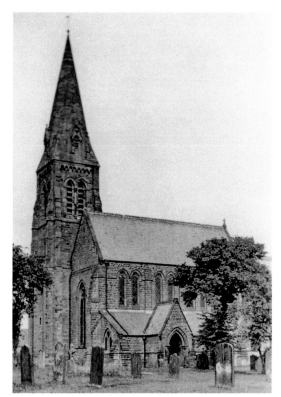

The South View of St Mary the Virgin's Church, West Rainton, 1920s
This church was designed by E. R. Robson and built in 1864 at a cost of £1,700. The tower and spire were added in 1877 and paid for by Sir George Elliot Bt. M.P., in memory of his daughter. The clock (by Potts of Leeds) was added to the north side of the tower in 1893, bought by public subscription in memory of Robert F. Boyd, a former churchwarden who held the office for thirty-one years. Further restoration was carried out in 1895.

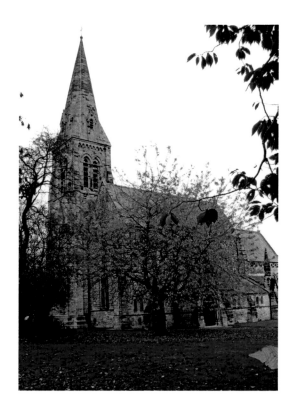

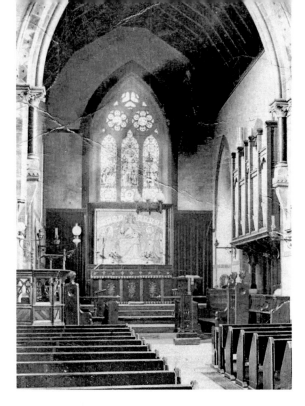

St Mary's Church, Chancel
The chancel of St Mary's Church, West Rainton, *c*. 1910. The fine mosaic reredos shows Christ in Glory with an angel on each side. The work was carried out by the Italian artist, Salviati, and was commissioned in memory of the second rector, the Revd. R. H. Poole. On the left is the original pulpit.

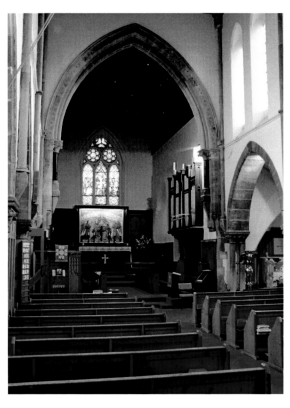

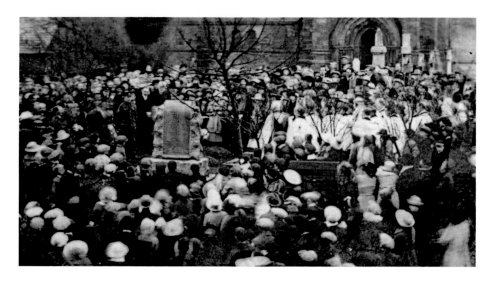

First World War Memorial

The granite roadside First World War memorial, West Rainton, taken by G. Dunn. It was unveiled by the Revd. J. Duncan, 13 November 1921, commemorating sixty men of the parish who gave up their lives in the Great War. The names of twelve from the Second World War were later added.

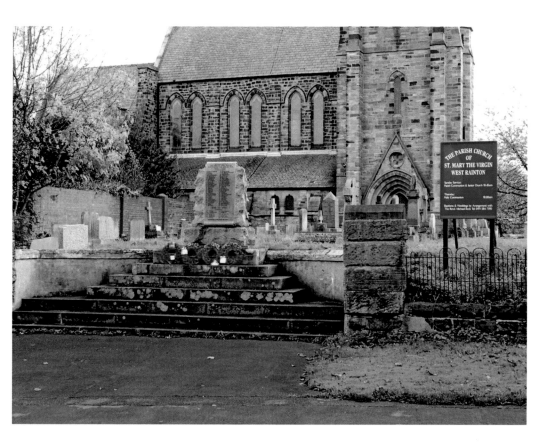

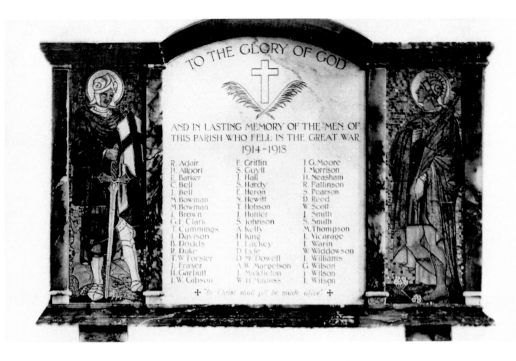

The First World War Memorial, Inside St Mary's Church, West Rainton

Photographed in the 1920s, the fine detailed mosaic and marble plaque, commemorates fifty-one men of the parish. The plaque was unveiled by Col. J. R. Ritson, 11 May 1921. It is now situated in the new north aisle chapel, which is dedicated to St Godric of Finchale.

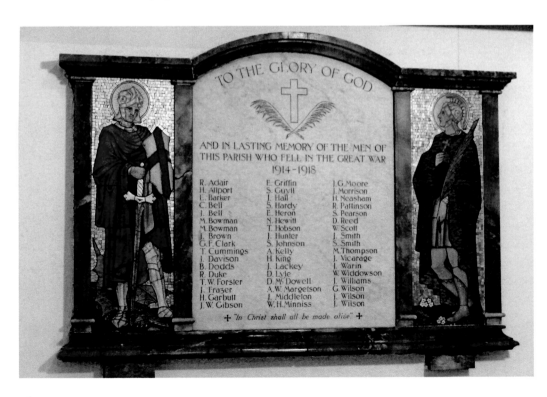

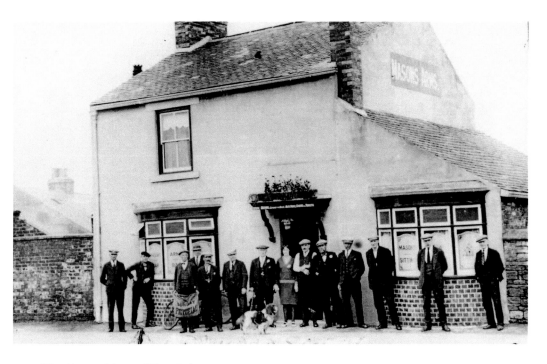

The Masons' Arms, West Rainton, 1930s

The landlord, wearing a waistcoat, was Isaac Brown. On the original photograph, the name 'Grandad Smith' is written, with an arrow pointing to the second figure on the left. The elderly 'paper-lad', third from the left, has the name *Sunday Pictorial* on his bag. The left bay window has the lettering 'BAR' and the one on the right says 'SITTING-ROOM'.

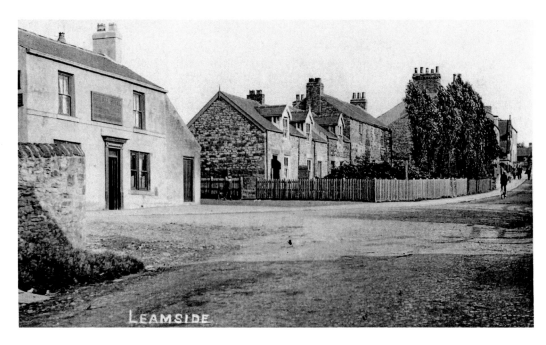

The Railway Hotel, Leamside, c. 1916
Named after the nearby station (the landlord was then Charles Harker), the hotel was situated at the bottom end of Station Road, on the corner before reaching the stone railway bridge.

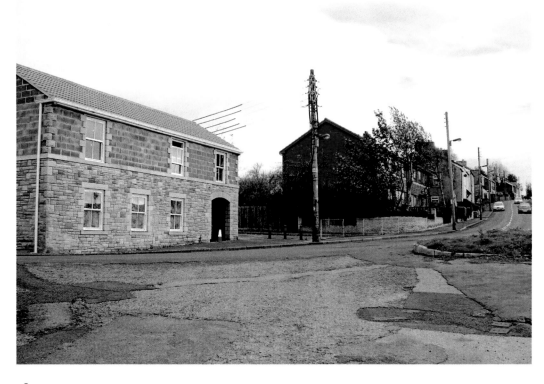

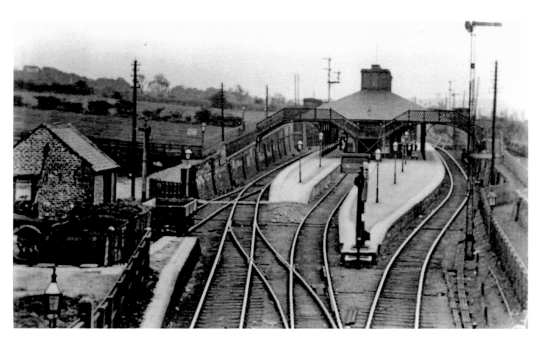

Leamside Railway Station

Photographed in the 1900s, Leamside Railway Station can be seen viewed from the stone bridge, which was built in 1848 (now Grade II listed). The line first opened in 1838 and linked up with the Newcastle connection in 1844. The station no longer survives and the line closed c. 1991-92, after being used for goods and main line diversions. Although mothballed the line still remains intact. The land to the left was later used by Mr Hardy of Carrville as a coal yard.

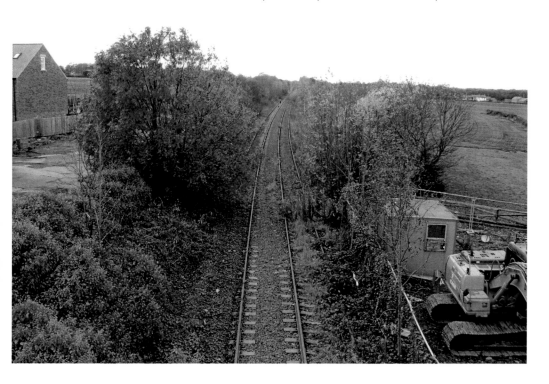

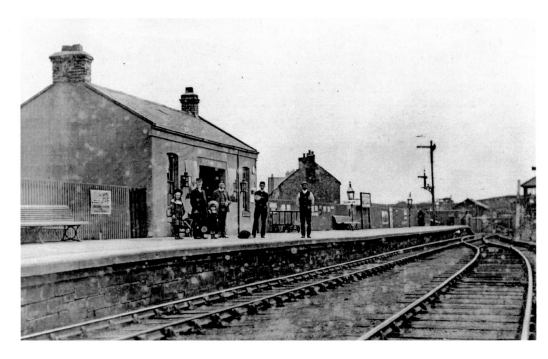

Pittington Station, Low Pittington, 1900s

This station was authorised 17 June 1875 at a cost of £383. It was situated a few hundred yards behind the present Blacksmith Arms public house. The line was part of the Durham Elvet and Murton branch and had opened in 1837. It closed to passengers in January 1953 and to goods in January 1960.

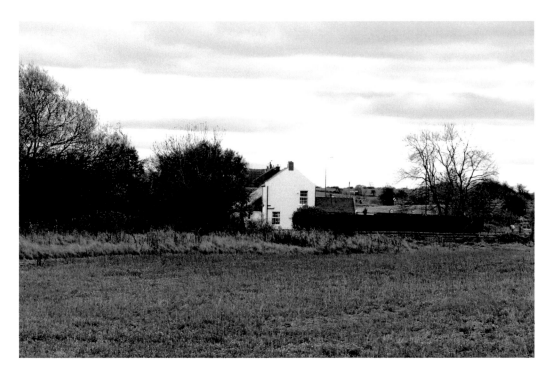

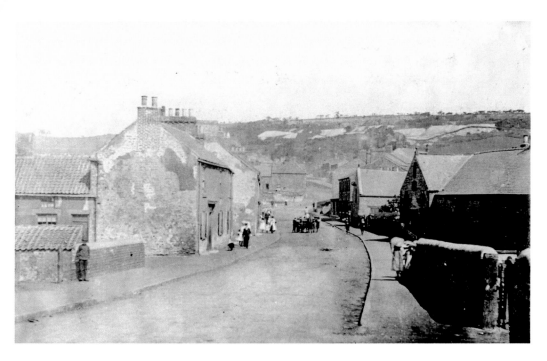

Looking Towards Low Pittington, *c.* 1904
In the distance is the old limestone quarry, which had closed in 1879. The higher ground of the village is the area that was called 'The Town'. On the right is the old school, which later became the institute and has since been demolished.

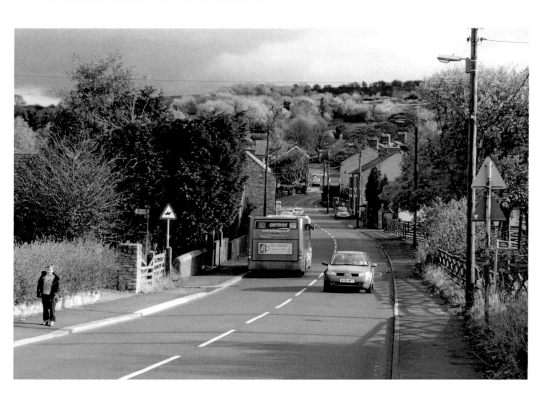

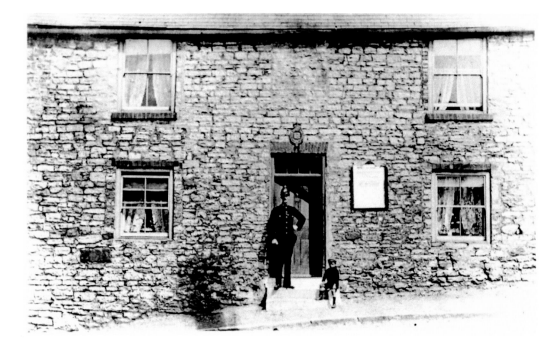

The Police House, Low Pittington, c. 1913

Note the police badge above the front door. The property had previously been the Three Horse Shoes public house. The policeman in the doorway was P.C. Sidney Walton and the little boy is his son, also called Sidney. P.C. Walton had joined the force in 1911 after serving with the Coldstream Guards. During military service in the Great War he was wounded at Ypres in 1914. He returned to his unit in February 1915. In early 1916, he was recalled to serve in the Durham County Constabulary, based back at Low Pittington.

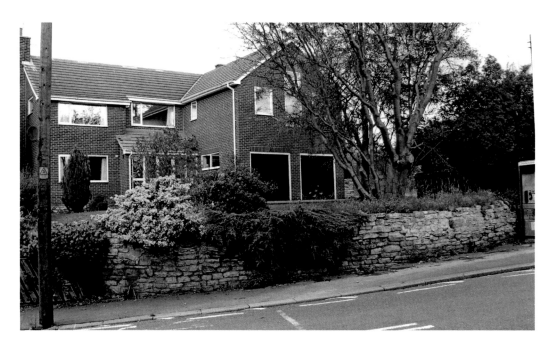

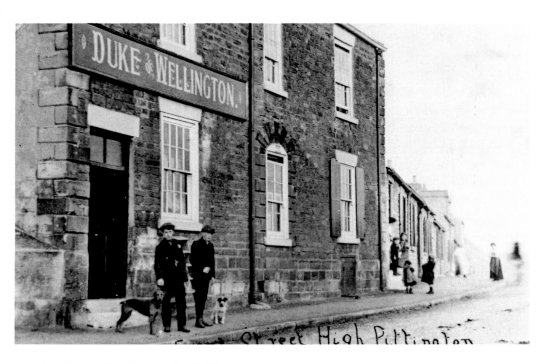

The Duke of Wellington Public House

This public house was in Front Street, High Pittington, *c.* 1904. This area was originally called New Pittington. The two boys are George W. Hutchinson (left) and his brother, James. The old miners' cottages on the right were called Wellington Street (now an open green area). The pub was named in honour of the 'Iron Duke' himself, after he had paid a visit to Pittington on his north-east tour in 1827 as a guest of Lord Londonderry.

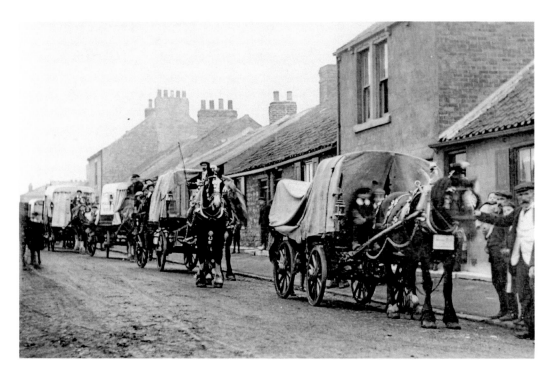

Parade Entrants

Reminiscent of a Wild West wagon train, parade entrants from the Pittington Co-operative Store, passing along Wellington Street, High Pittington, 1900s. Many villages then had annual parades involving the whole community, usually organised by store members. Some of the villages around Durham also took part in the larger annual Durham City Horse Parade.

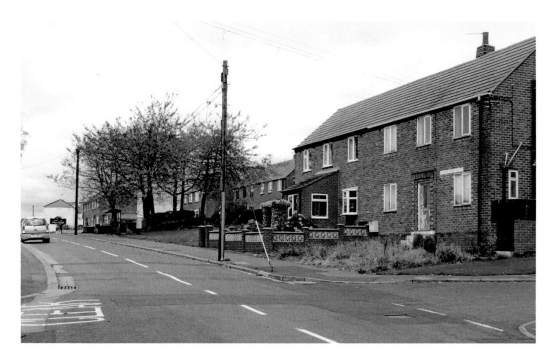

Calvary Cross

Pittington First World War memorial in the form of a Calvary cross, commemorating thirty-seven local men. It was designed by W. H. Wood of Durham and sculpted by Bowman and Sons, Stamford. The photograph was taken shortly after it was unveiled, 19 June 1920, by Canon Martin. It was dedicated by the vicar, Canon Samuel Guest-Williams (died 11 December, 1920). He had four sons who served in the Great War. One of them, Captain W. A. Guest-Williams, was killed 25 September 1915, aged twenty-six, and is commemorated on this memorial. The names of those from the Second World War were later added. The cross stands on the south side of St Lawrence's church, near the porch.

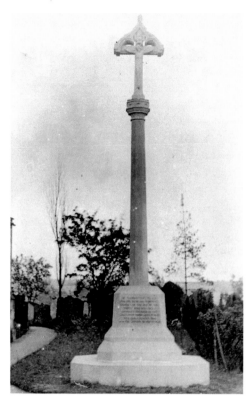

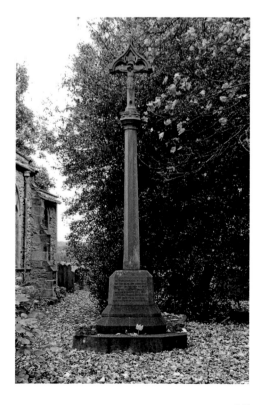

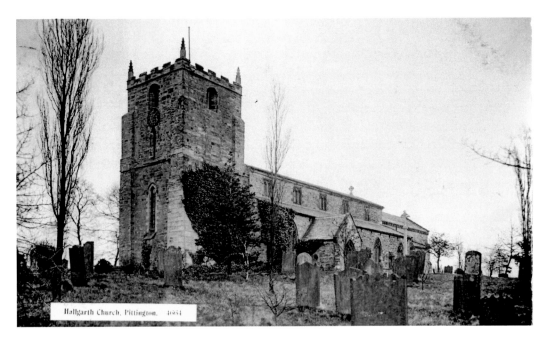

Hallgarth Church, Pittington. 4664

St Lawrence's Church (Grade I listed), Hallgarth, Pittington
Shown here in the 1920s (photograph taken by R. Johnson) this building has been a place of worship since about 1100. Some archaeologists believe it was built on the site of an earlier wooden church. The oldest part of the church is the westernmost section of the nave. From the north aisle, if one looks up towards the top of the nave wall (above the arches), the twelfth-century former outer wall is visible.

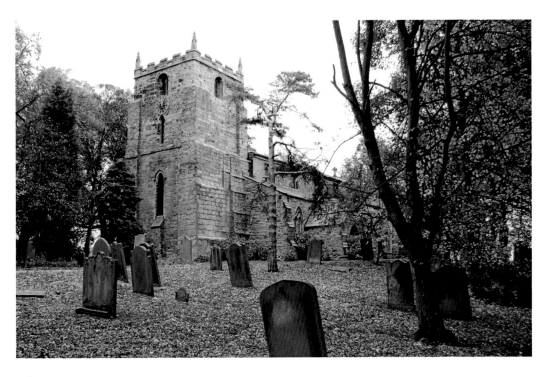

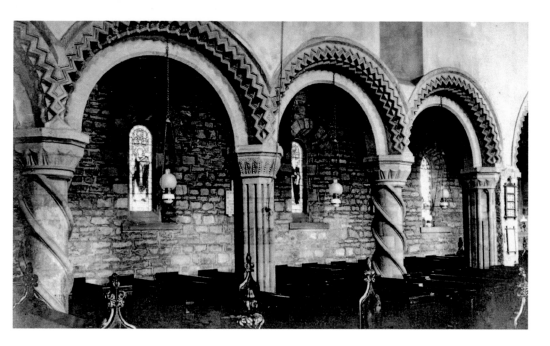

Inside St Lawrence's Church, Hallgarth, Pittington
The photograph, from the 1900s, taken by W. Wilkinson, shows the fine Norman north arcade (c. 1180-95 suggests Peter Clack). Sir Nikolaus Pevsner describes this as, 'One of the most exciting pieces of architecture in the county.' The church was heavily restored 1846-47 by architects, Ignatius Bonomi and John Augustus Cory. More restoration work was carried out by W. S. Hicks in 1897-99 and also in 1905, when the chancel was altered.

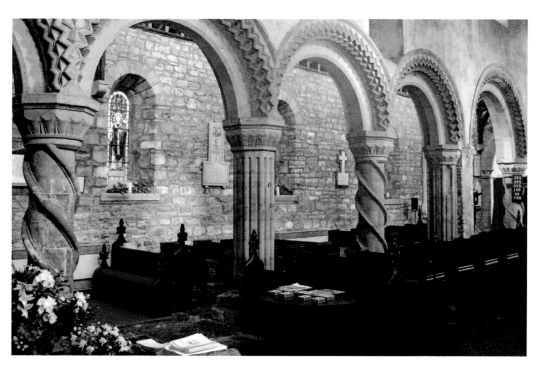

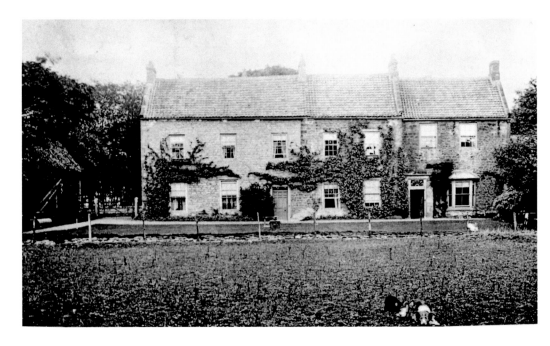

Hallgarth Manor
Now Hallgarth Manor Hotel (Grade II listed), Hallgarth Farm, Pittington, is pictured *c.* 1905. At the time of the photograph it was lived in by the Clarks. Prior to becoming a hotel, it was the home of the Glen family. It was first constructed in the mid-eighteenth century and extensively altered in the nineteenth century. The picture shows what is now the rear of the present building. A cat and dog are noticeable in the bottom right corner.

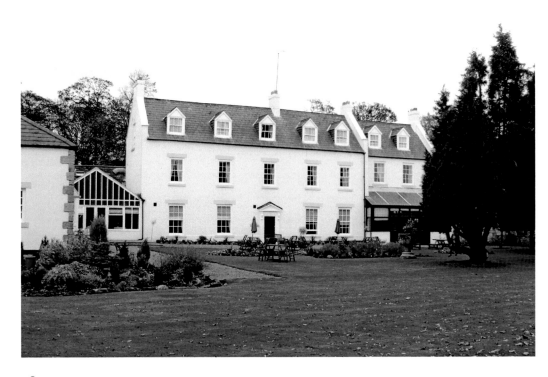

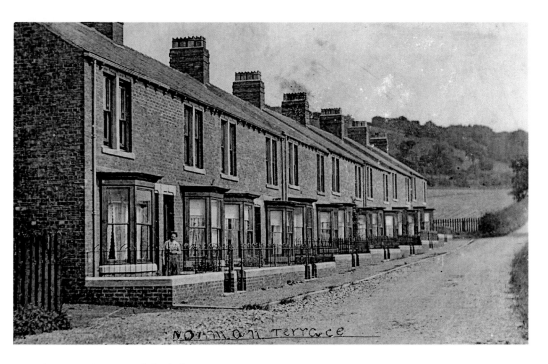

Norman Terrace, High Pittington, *c.* 1913

The street is located on the Easington Road, near the crossroads, built, *c.* 1911 by Frank Goodyear and named after his son. Note the lady at the door of number 1. The iron railings in front of these houses were removed for the war effort, 1939-45.

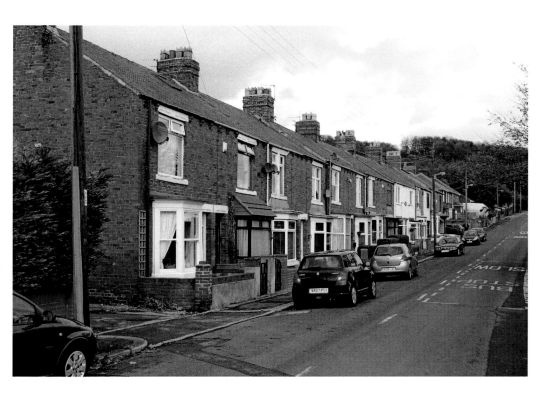

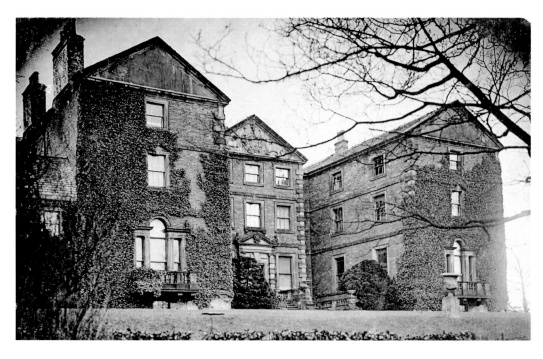

Elemore Hall, Near Pittington, c. 1910

It was originally a stone-built Elizabethan manor house, traces of which survive in the basement area. This, the new house, was built for George Baker in 1749-53 by architect and mason Robert Shout of Helmsley. In the 1950s, the hall became a residential school for children with special needs, run by Durham County Council.

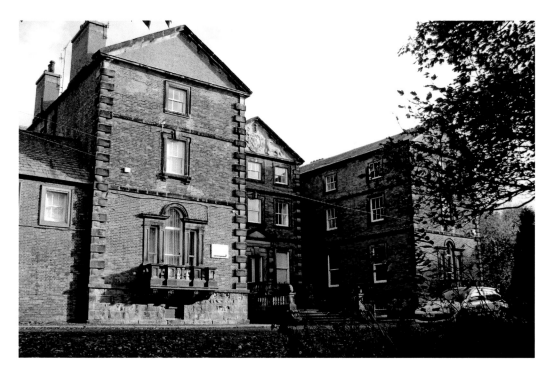

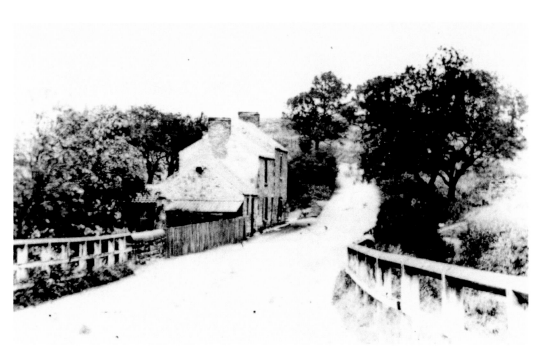

The Bird in the Bush Inn, Coalford Lane, Pittington, c. 1920
It stood near Coalford Bridge, between High Pittington and Littletown. Immediately opposite (on the other side of the road) was a cockpit, where cock fighting took place before it was outlawed in 1849. Demolished in about the 1950s, the site of the inn is now used as a grazing paddock.

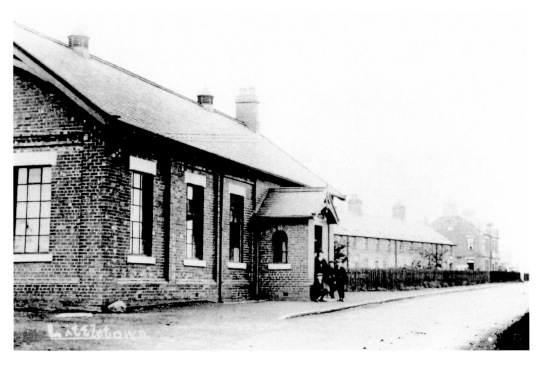

The Miners' Institute, Littletown, *c.* 1913
It was opened in 1907 with a well-equipped reading room and two professional billiard tables.
The building was removed in the 1970s after many years of vandalism. The large property on the
far right is the former Duke of York public house.

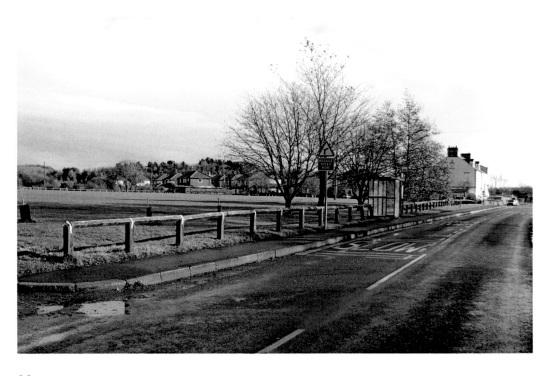

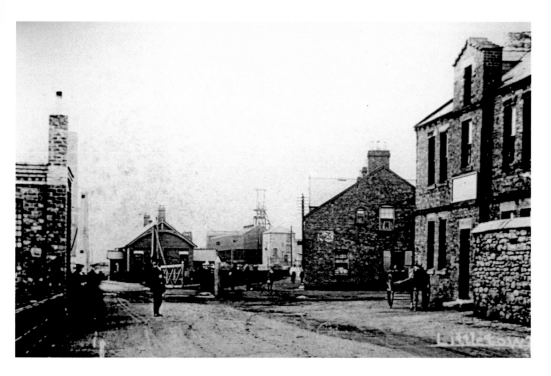

'The Crossing', Littletown, c. 1910

This was where one of the wagon-way lines belonging to the pit crossed the main street towards Sherburn Hill Colliery. The tall building on the right is the Duke of York public house, built in 1894 (now a private residence). Adjacent to it is Littletown Post Office. The two central buildings in the distance are: left, the Miners' Institute and right, Littletown Colliery (closed by 1913).

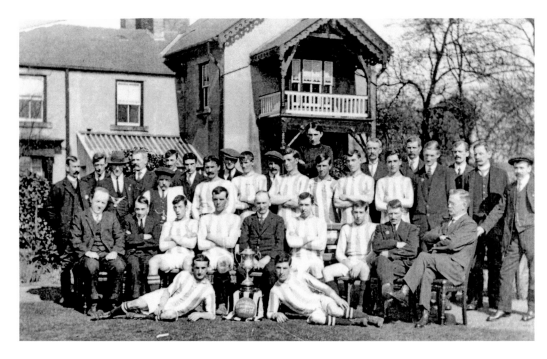

Littletown Institute A. F. C., League Champions, 1917-18
Photographed outside Littletown House, then the home of George Hornsby, mining engineer, viewer and agent for Littletown and Sherburn Hill Collieries. The earliest recorded name for the village was South Pittington, later Little Pittington, and in 1613, Littletown, which was probably the name of a nearby farm.

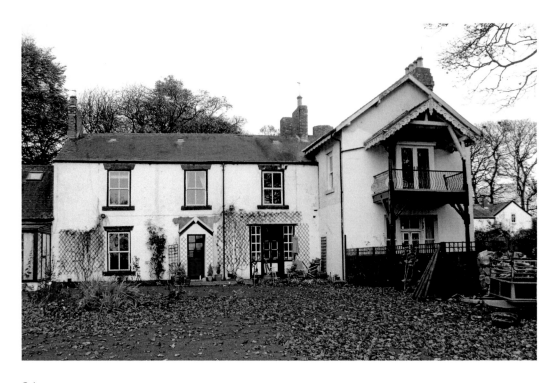

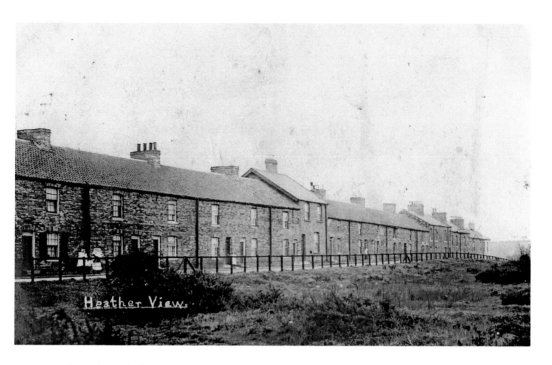

Heather View, Littletown, c. 1911

These miners' cottages were lived in up until the early 1970s (demolished in 1975). The name Heather View is an indication of the once-pleasant outlook the residents would have had, over looking a meadow and the first village cricket ground. This was prior to the ever-increasing rise of Sherburn Hill pit heap, which later towered above the surrounding area. The 'heap' was lowered between 1969-72, from 583ft to 440ft, at a cost of about £105,000.

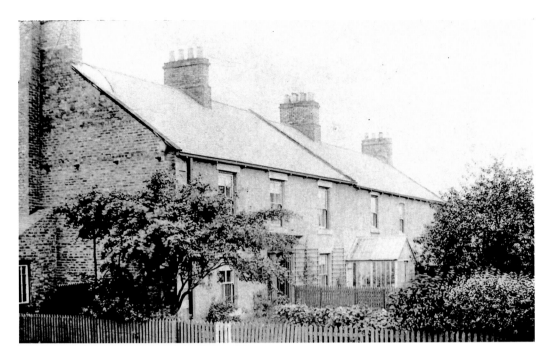

Moor View, Littletown, *c.* 1910

The photograph shows the west gable end of Moor Cottage. This small terrace was situated to the north of the village, near the old Wesleyan chapel. The area was then described in Kelly's directory as being a colliery village, consisting of numerous houses, occupied by pitmen. The village now mainly consists of Moor View and one street of council houses called Plantation Avenue.

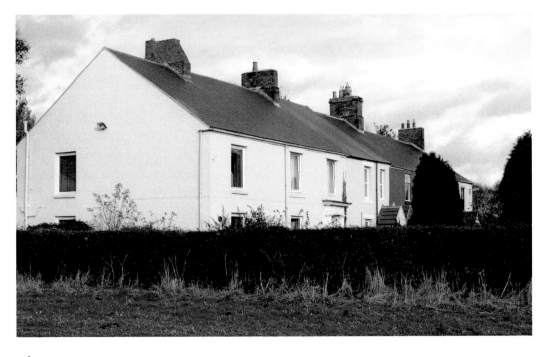

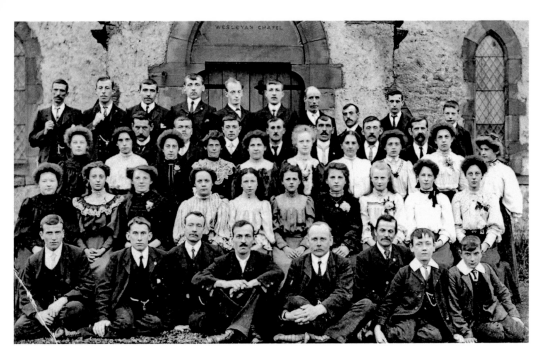

The Congregation Outside the Wesleyan Chapel, Littletown, 1900s
The building was opened in 1858 to seat 250 people and cost about £300. It continued in use until 1979. For almost thirty years it has slowly deteriorated; most of that time it was used as a joiner's workshop. It is now, in 2009, being converted into a private dwelling.

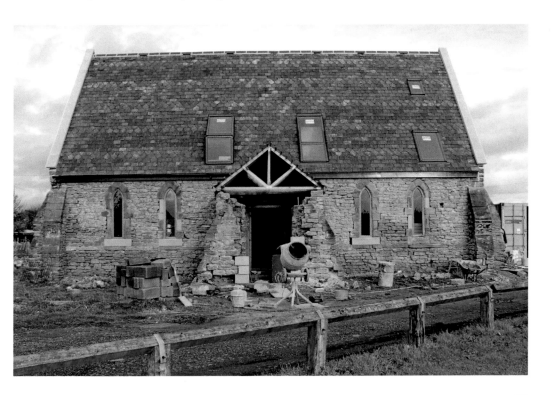

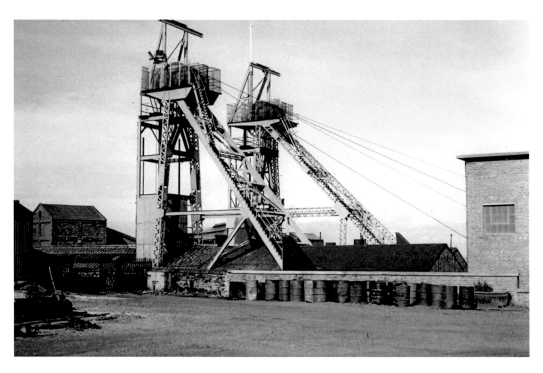

Sherburn Hill Colliery, c. 1960, taken by Billy Longstaff
In the 1950s, 938 men were employed here, producing 7,600 tons of coal a week. The east shaft was commenced in 1830 and the west shaft in 1835 (N.C.B Records). A surface-drift was started in 1951 to allow the hauling-out of coal-tubs. The barrels in the foreground were used to store engine-oil. The colliery closed 7 August 1965.

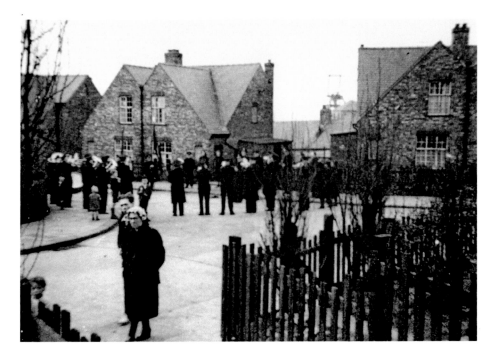

Kell Crescent Council Houses, Sherburn Hill, 1949

Kell Crescent Council Houses, built in the 1930s, were named after Councillor G. P. Kell. The photograph shows the local Salvation Army Band performing. These homes were erected to re-house coal-miners living in the old colliery rows. In the background, between the houses, one of the two shaft-heads belonging to the pit can be seen. The house on the right (along with three others) was later demolished due to subsidence caused by the opening of the surface drift in 1951. The two people walking together across the bottom left corner are Mrs Martin and her son.

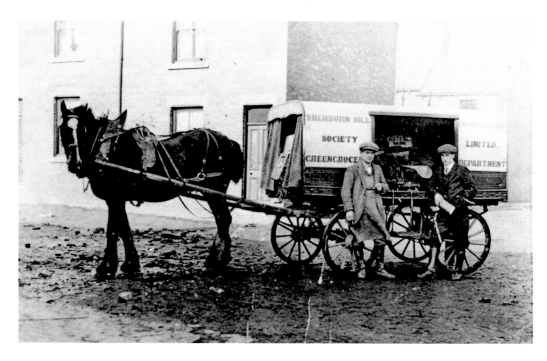

Horse and Cart, Sherburn Hill Co-operative Store

A horse-drawn greengrocer's cart from Sherburn Hill Co-operative Store, at the corner of South View (with North View behind), 1920s. The area at the bottom of Sherburn Hill (towards Littletown), was called the 'Busty', after a seam at the pit. This area was mainly occupied by coal miners. Note the poor state of the road.

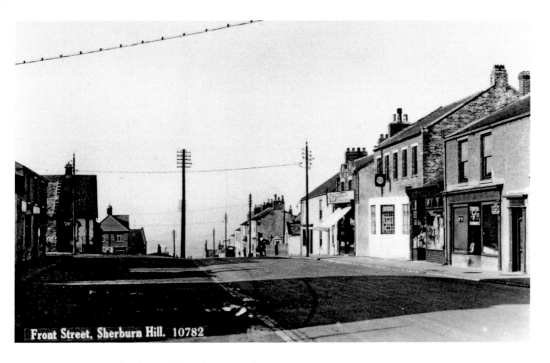

Front Street, Sherburn Hill. 10782

Front Street, Sherburn Hill at its Summit, 1920s

The Lambton Arms public house is on the extreme left. On the opposite side of the road are the business premises (left to right) of Walter Willsons' grocery store, the Seven Stars public house, Atkinson's grocery shop and the premises of A. E. Chapman the tailor (father of Dr W. E. Chapman, a well-known local GP).

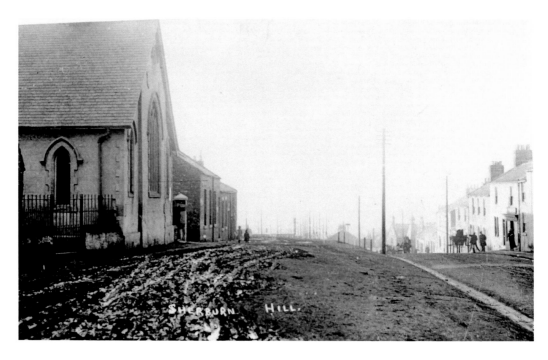

The Old Wesleyan Chapel, Sherburn Hill, c. 1912

It was built in 1857 at a cost of £270 and was enlarged in 1884 to seat about 400. Redundant by about the 1960s, it later became an optical factory and is now a private residence. The condition of the muddy upper access road is probably due to the construction of the former Sherburn Hill Co-operative building (see the scaffolding poles in the distance).

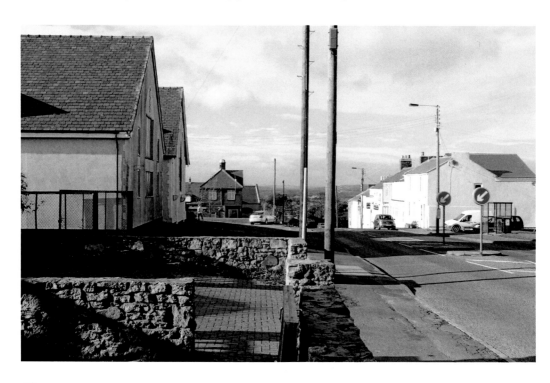

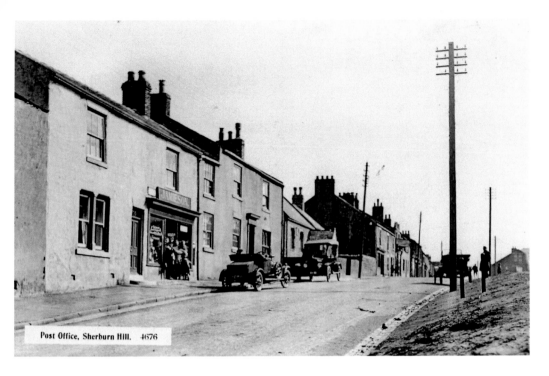

Post Office, Sherburn Hill. 4676

The Post Office, Sherburn Hill

The old photograph was taken in the 1920s by R. Johnson of Gateshead. The proprietor was then called Jamieson (see name above shop). The business closed some years ago; it is now (October 2009) a tanning and beauty salon.

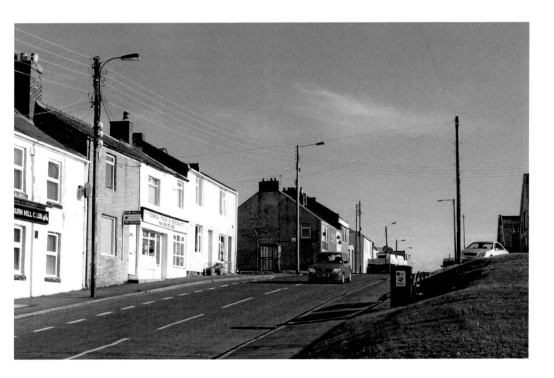

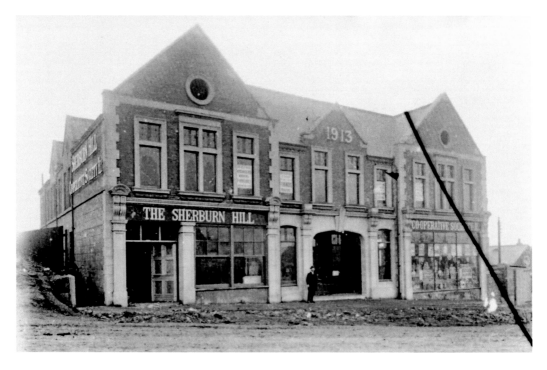

Sherburn Hill Co-operative Store, 1913

The first meeting of the Co-operative Society was held on 12 December 1873. Shortly after, in January 1874, the members acquired the use of a colliery house to do business. About three years after this, they had built up enough capital to build their first store, which, in turn, was rebuilt in 1913. The premises are now used as a furniture store.

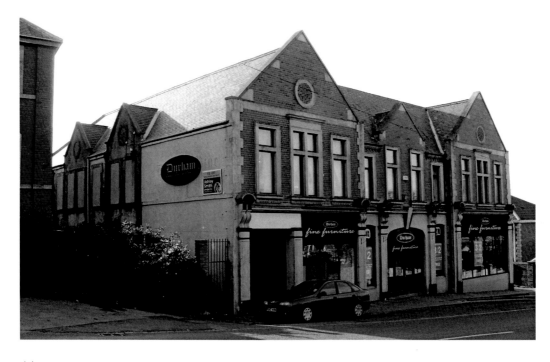

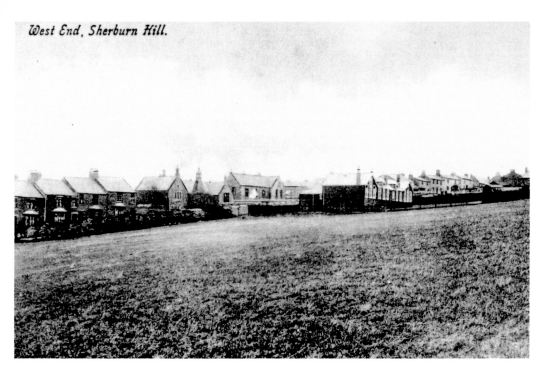

'West End', Sherburn Hill, 1900s

'West End' is shown here prior to the building of the Durham Aged Mine Workers' Association homes. These were officially opened in three stages, 1923, 1924 and 1931. The houses on the left are Wesley Terrace, built 1903. On the right is the old girls' school, built 1908 (known locally as the 'Tin School'). The site is now occupied by several large houses and is called Palatine View.

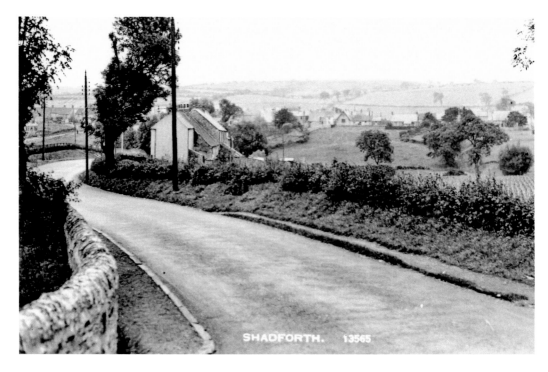

Shadforth Village

Looking towards the centre of Shadforth Village from outside the church gates, late 1920s. The houses on the right of the road are Church Villas, situated on Church Lane. The name Shadforth means 'shallow ford'; its origin can be traced back to the Boldon Book of 1183, when it was called 'Shaldeford'.

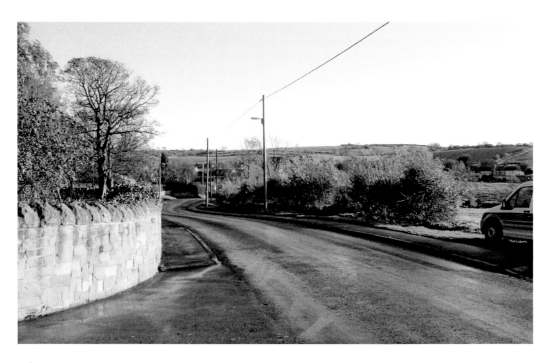

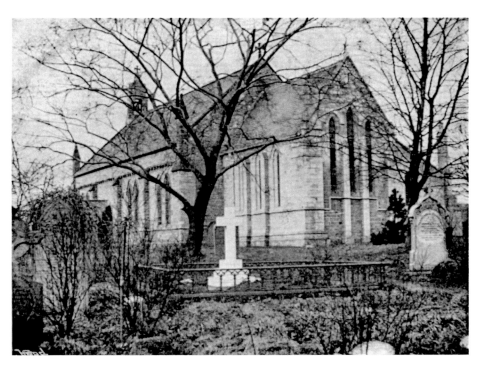

St Cuthbert's Church, Shadforth, 1900s

Designed by Thomas Jackson, the church was consecrated by the Rt. Revd. Edward Maltby, Bishop of Durham, 15 August 1839. The building was restored 1890-91 by Hicks and Charlewood, when the chancel was rebuilt and heightened at a cost of £2,000. The nave was restored in 1917 by W. Caroe, architect, of London.

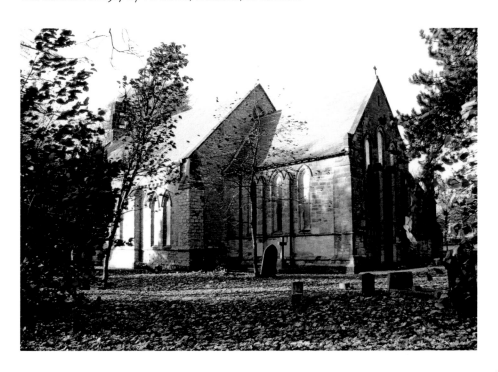

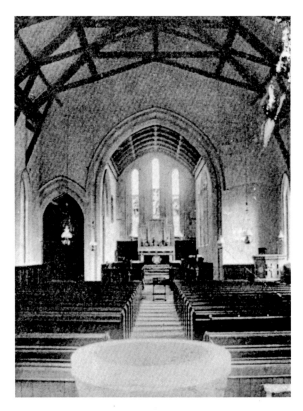

St. Cuthbert's Church,
Shadforth, c. 1910
This view of St Cuthbert's church
is looking down the nave from the
font area, towards the chancel. The
old oil-lamps, which are visible, were
then used to light the church, before
the introduction of electricity, about
1926. The year 2009 marked the 170th
anniversary of the church.

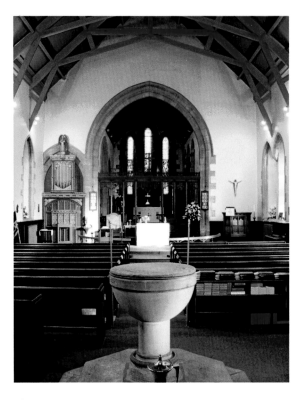

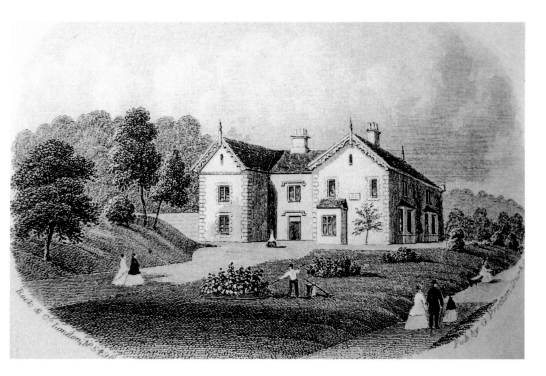

Shadforth Vicarage

Pictured is the elegant Shadforth vicarage, 1870s, engraved by Rock and Co., of London, published by George Proctor, Durham. Situated a little way behind the church, it was erected by Benjamin Adamson. After many years of dilapidation it was sold, along with its land, in 1967, for the grand sum of £5,600. It is now a private residence.

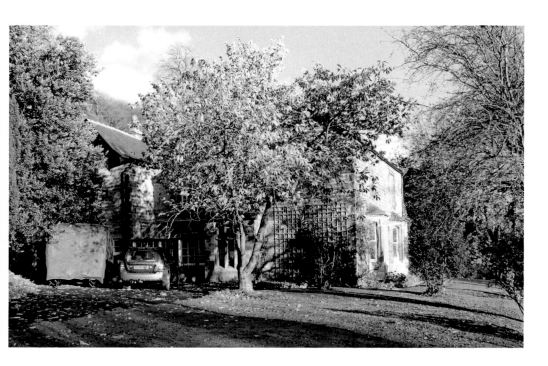

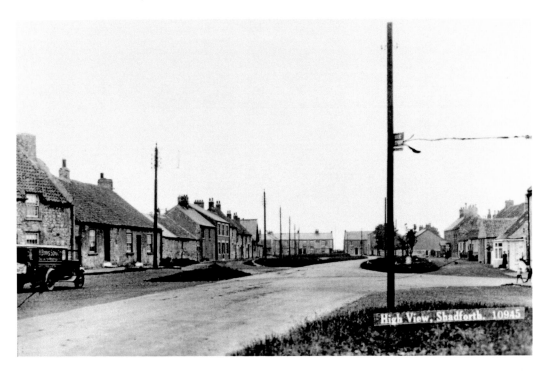

High View, Shadforth, 1920s

Viewed looking towards the west end of the village. A Binns department store van is making a delivery on the left; on the right, attached to a telegraph pole, is a sign for the public telephone. The population of the village was boosted in the 1930s, when a large number of council houses, named collectively as Woodside, were built. Today, the village is a pleasant mix of council and private dwellings.

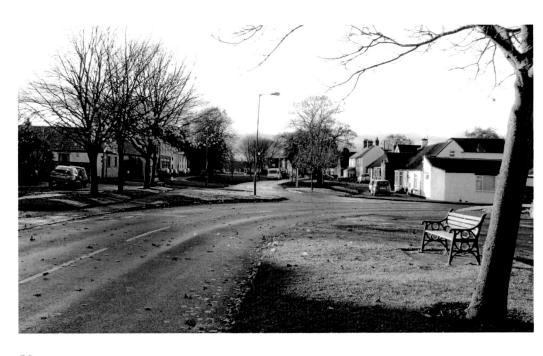

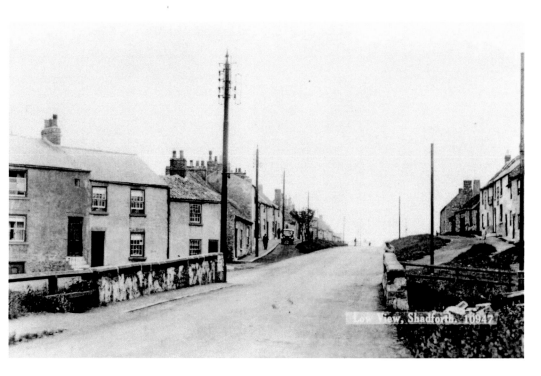

Low View, Shadforth, 1920s

Viewed from the east end of the village, this photograph was taken by R. Johnson. This area was known as the 'Bottom End' and was near the bridge. The whitewashed building on the right was the former Saddle Inn, now a private house called The Old Saddle (see p. 52).

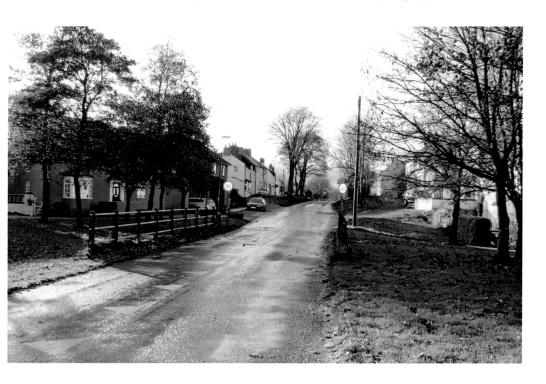

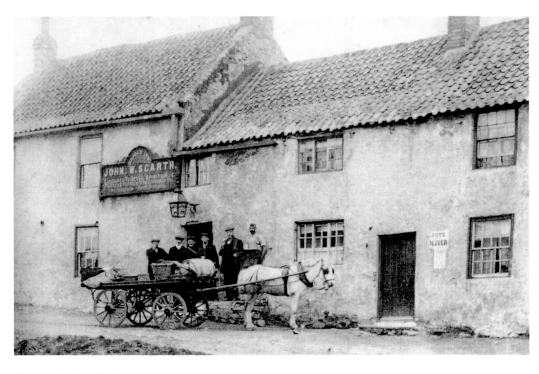

The Saddle Inn, Early 1900s
The landlord at this time was John W. Scarth. An election poster on the wall reads 'Vote Oliver'. The cart is loaded with a barrel of ale and a basket of sandwiches to take out to farm labourers working in the nearby fields.

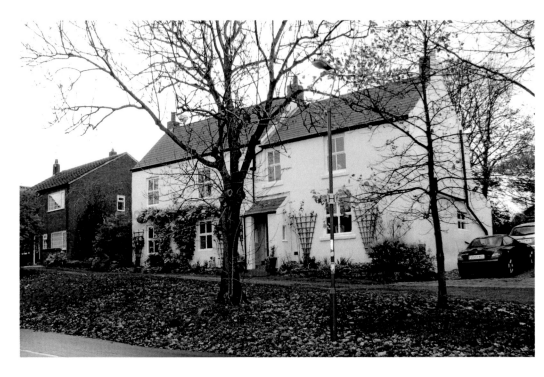

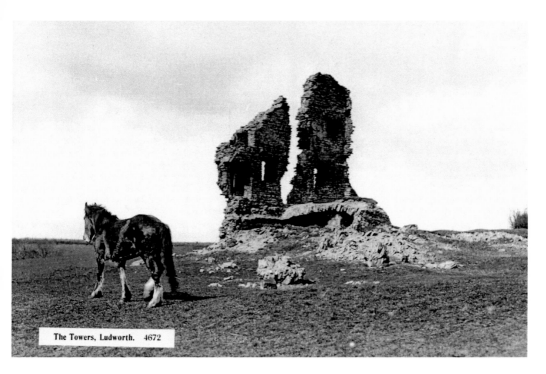

The Tower, Ludworth, c. 1923, taken by R. Johnson

The photograph shows the west wall of the former tower, which originally consisted of three storeys over a vaulted basement. The tower formed part of a larger manor house, which was fortified by Thomas Holden in 1422, by licence of Bishop Langley. It is now cared for by Durham County Council.

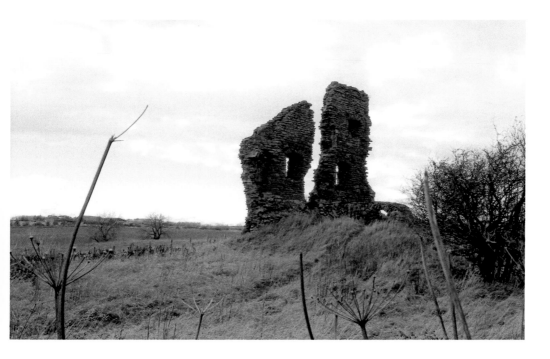

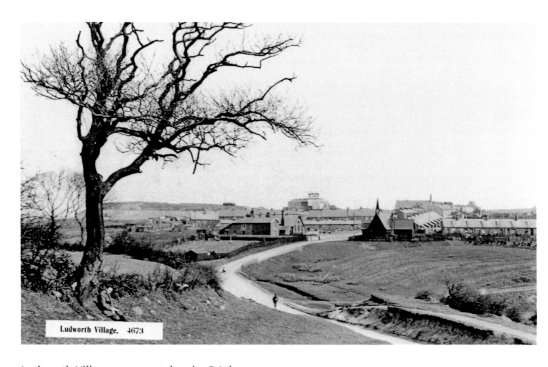

Ludworth Village, c. 1923, taken by R.Johnson

On the skyline, in the centre, is Ludworth Colliery (sunk 1837, closed 1931). Centre right is St Andrew's (wooden) mission church, which was erected 1902, at a cost of £1,000 (destroyed by fire in the early 1980s). About 1210, the village of Ludworth had been in the possession of the de Ludworth family; by the late fifteenth century it was largely deserted.

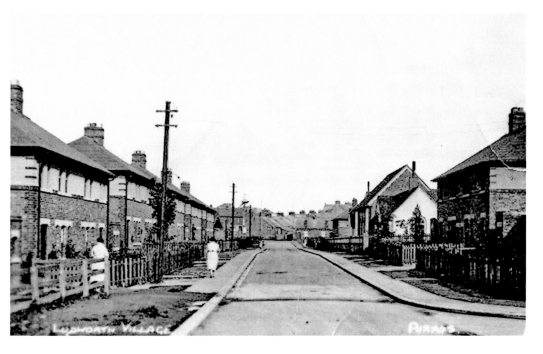

Moor Crescent Council Houses, Ludworth, 1930s
Like those at Sherburn Hill, these were built to re-house coal-miners and their families. They had previously lived in the old colliery rows, which, by this time, had become dilapidated hovels, with no bathrooms or inside toilets. On the centre skyline is the winding-tower belonging to Ludworth Colliery.

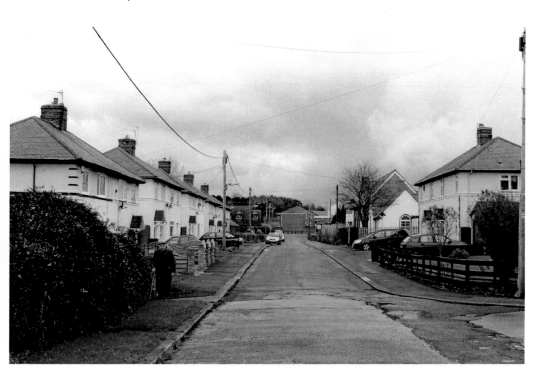

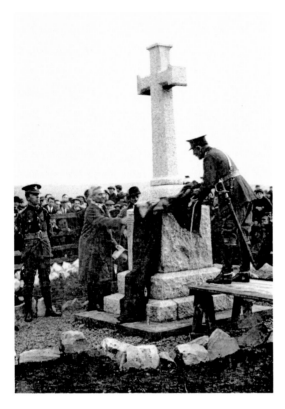

The Unveiling of Ludworth First World War Memorial

In 4 March 1927, the war memorial was unveiled by Col. J. R. Ritson, and the service was conducted by the Revd. A. C. Hague, assistant curate of Shadforth church. The memorial commemorates nineteen men of the village. Later, the names of those lost in the Second World War were added. The cross and surroundings were refurbished in 2005.

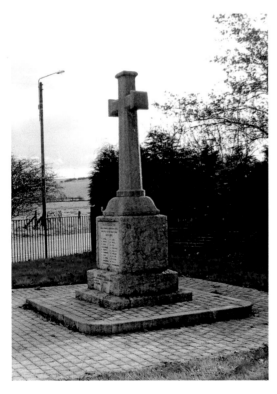

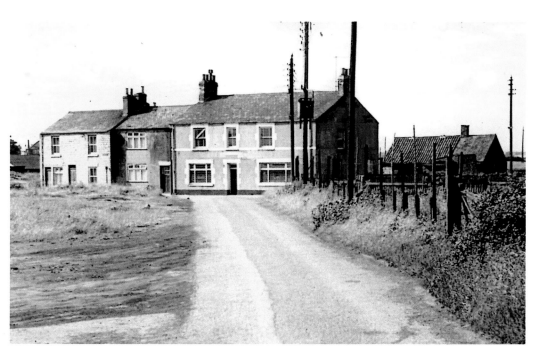

The Foresters' Arms

The Foresters' Arms, 55 Front Street, Sherburn Village, *c.* 1960, taken by Billy Longstaff. This public house was a popular venue for youths in the late 1950s and early 1960s; it was well known for its champion darts team. The site is now occupied by two houses (built early 1970s). The road in the foreground led to Quarry Cottages.

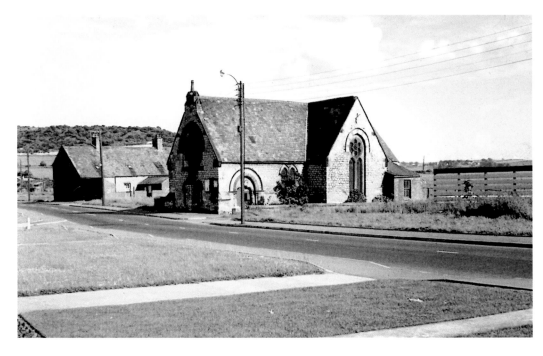

Sherburn Village Wesleyan Chapel

The Wesleyan Chapel, Sherburn Village, *c.* 1960, taken by Billy Longstaff. It was opened in 1861 at a cost of £600. The limestone chapel no longer survives and the site is now occupied by bungalows named Chapel Court. The pit cottages on the left are called New Street; in the distance, above the rooftops, is part of Sherburn Hill.

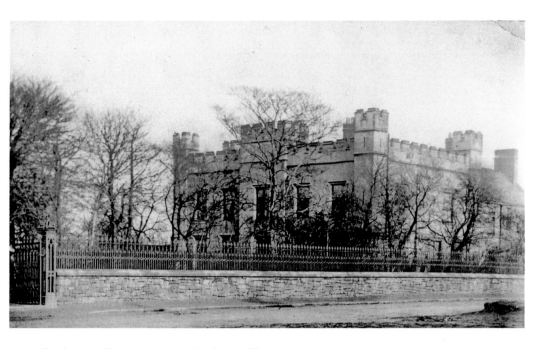

Sherburn Hall, Front Street, Sherburn Village, c. 1904

The hall had at one time been occupied by the Tempest, Hopper, Thompson, Coulson and Pemberton families. In its later years, part of it was used by Dr Alexander Harrison as his surgery. Finally, it was used as a council depot. It was taken down in 1951, and the last remains of rubble were removed in 1952. The area of the hall is now partly occupied by aged persons' bungalows called Kinnock Close.

Hall Farm, Sherburn Village, *c*. 1960, taken by Billy Longstaff
The Dobson family were the last occupants. It was replaced by modern houses named Peart Close. Note the pantiled rooftops belonging to the small shops on the left (see p. 62). The curved garden wall on the right belonged to the former Sherburn Hall.

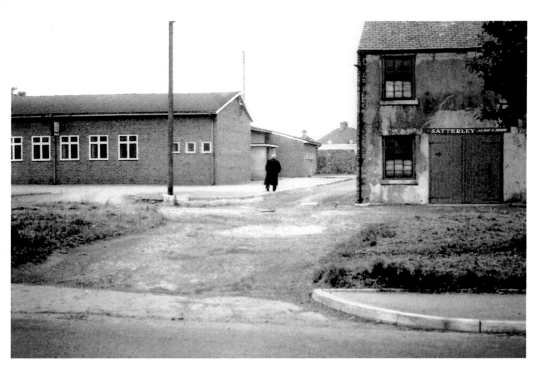

Sherburn Village Working Mens' Club

The club was opened in 1959 by Mr. S. Lavery and was situated at 60 Front Street. The photograph was taken *c.* 1960 by Billy Longstaff. The site had previously been the coachyard, stables and associated outbuildings of Sherburn Hall, which stood on the opposite side of the road. The garage on the right belonged to Satterleys, who sold hardware in the surrounding villages from a car and covered trailer. The ground floor is now occupied by a hairdresser.

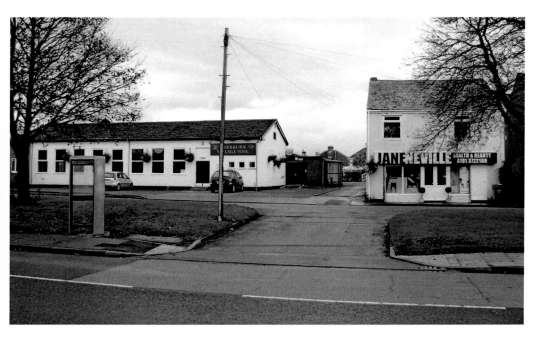

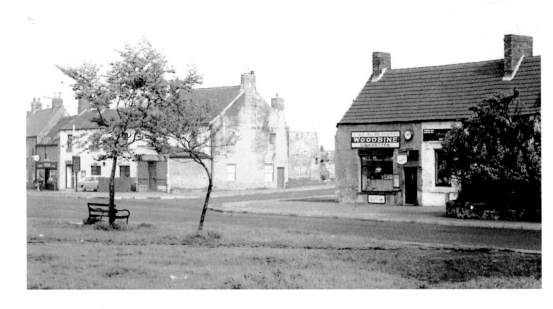

The 'Crossroads'

The 'Crossroads', Sherburn Village, c. 1960, taken by Billy Longstaff. The road on the right, Hallgarth Street, leads towards Pittington. The newsagent's on the corner was then run by J. and G. E. Allan. The building on the opposite corner was Cairn's fruit and vegetable shop, 21 Front Street (now Gatenby's carpet, furniture and electrical store). Left of that is the Lambton Arms public house.

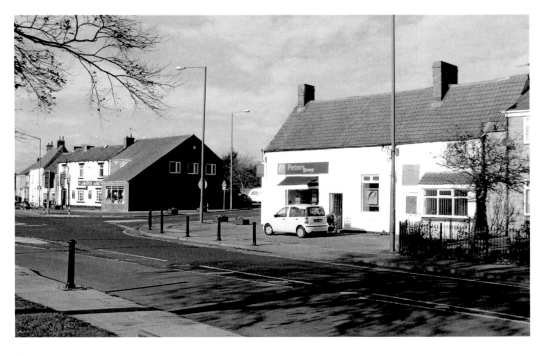

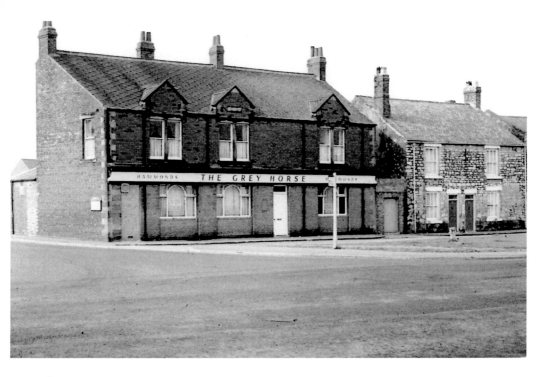

The Grey Horse

Rebuilt in 1915, the Grey Horse, 70 Front Street, Sherburn Village, is shown *c.* 1960, photographed by Billy Longstaff. The houses on the right were demolished in the 1960s to make way for a village car park. The public house closed around 2001-2, and it is now a carpet and flooring showroom.

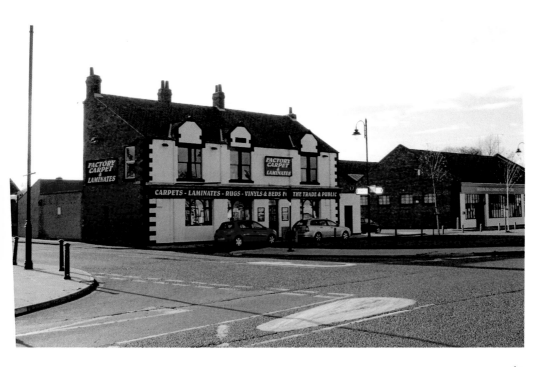

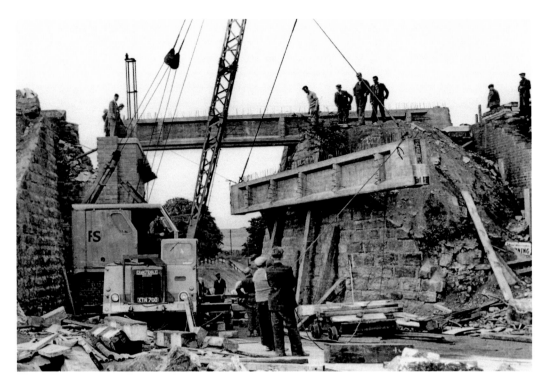

Mill Lane

Replacing the old stone railway bridge, Mill Lane (near The Crescent council houses), Sherburn Village, 1960, taken by Billy Longstaff. This linked Sherburn Hill Colliery with the coal-sidings at Sherburn Station. The new bridge was completely removed in the 1980s, and part of the line is now laid out as a public walkway.

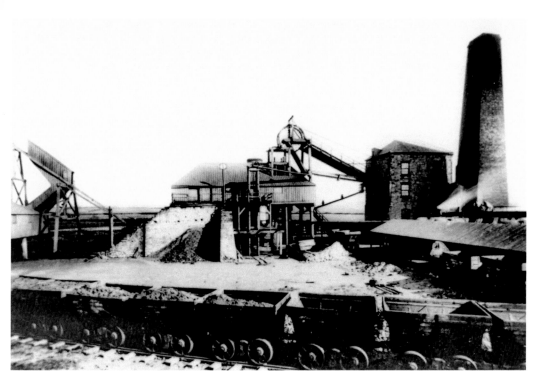

Sherburn House Colliery, 1890s

The pit, which was opened 1844 and closed May 1935, was first leased to the Earl of Durham, later to the Lambton Collieries and later still to the Lambton and Hetton Collieries. In 1913, Sir B. Samuelson and Company. took over the lease; finally, in 1923, Dorman Long and Company held it. The site was opposite Grand View council houses, south of the village, in the direction of Bowburn.

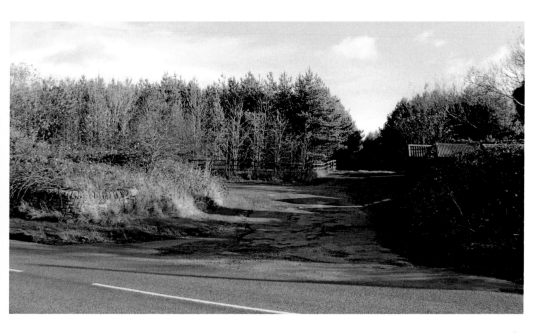

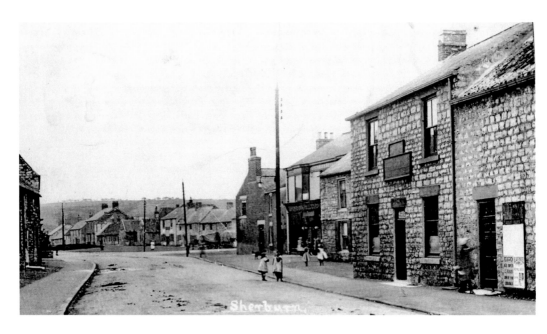

Sherburn Village, looking towards the Crossroads
Pictured from the Durham end *c.* 1914, the public house on the right is the Cross Keys, 86 Front Street. The second property to its right is a branch of the Sherburn Hill Co-operative store. The name, Sherburn, comes from the old English words meaning 'the clear stream' and was first recorded *c.* 1150 (see *A Dictionary of County Durham Place-Names*, Victor Watts, 2002).

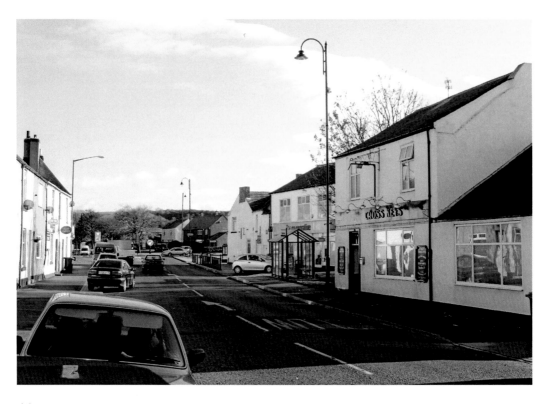

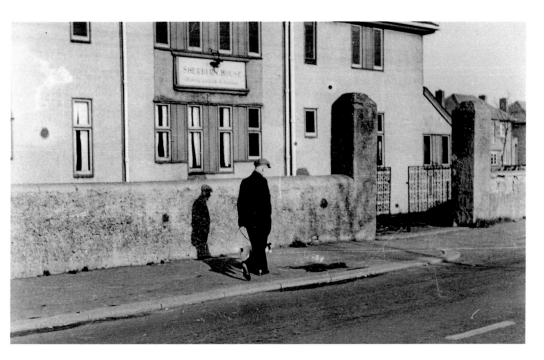

Sherburn House Miners' Welfare and Social Club, *c.* 1964

The Welfare was opened in 1929 for Sherburn House Colliery. When the pit closed in 1935, it was taken over by the Welfare Commission, and in 1952, it was run by Sherburn Hill Colliery. The building closed in 1965, and was destroyed by fire on the 28 March 1967. On the extreme right is one of the village police houses in Liddle Avenue.

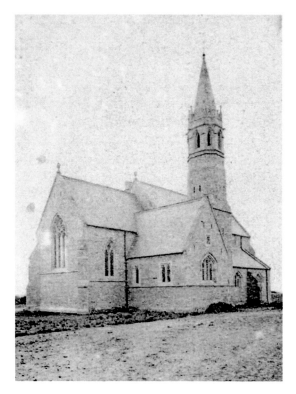

St Mary's Church, Sherburn Village
The church is shown in the 1870s and the photograph was taken by Thomas Heaviside. It was consecrated 28 May 1872 by the Rt. Revd. Charles Baring D.D., Bishop of Durham (a member of the famous banking family of Baring Brothers). The architects were Austin and Johnson of Newcastle, and the builder was Robson and Son of Durham. The total cost was about £3,500.

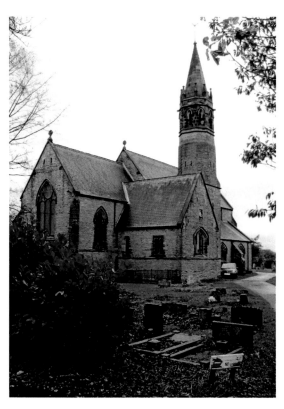

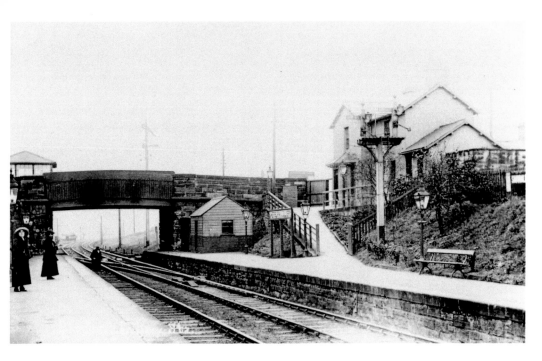

Sherburn Colliery Railway Station from the North, 1900s
It was situated on the Leamside line, west of the village. On the right, what was then the Station House is now a small portion of ground occupied by out buildings. It closed to passengers in 1941 and to goods in 1959.

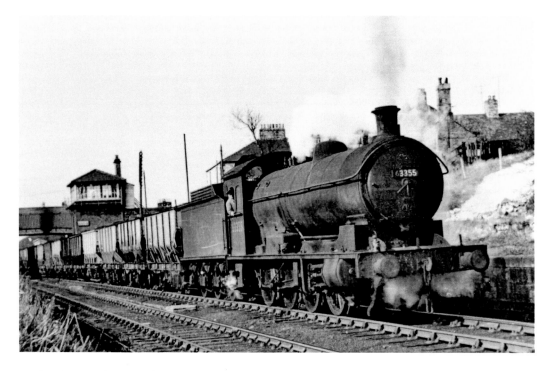

Coal Train, Sherburn Station
A coal train passing through Sherburn Station towards Shincliffe, 1957, taken by Billy Longstaff.
To the right of the signal-box, in the distance, between the telegraph poles, is the top of the old
winding-tower of Lady Durham Colliery (1873-1919).

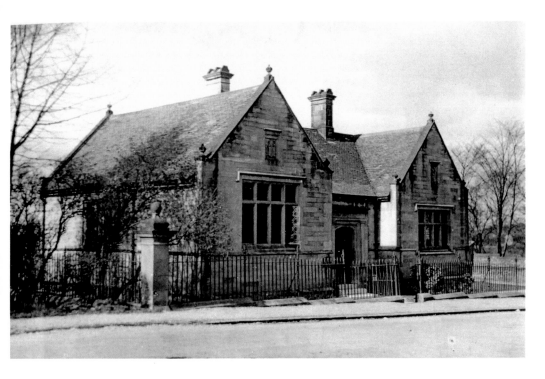

The Dispensary, Sherburn House, 1890s

The first establishment to give free out-patient treatment had opened in 1858. This, the new structure, was built 1883 (see date on the stained glass window on the left bay); it was designed in the Tudor-style by local architect C. Hodgson Fowler at a cost of about £2,000. It is now used as a 'dry-house' for recovering alcoholics.

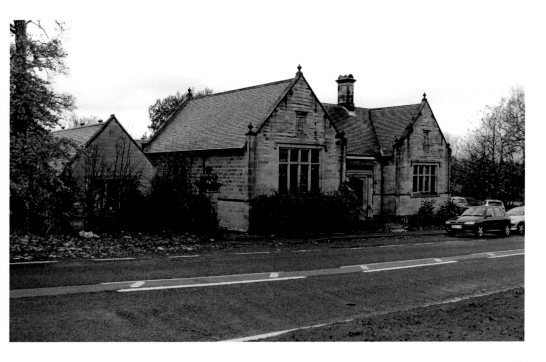

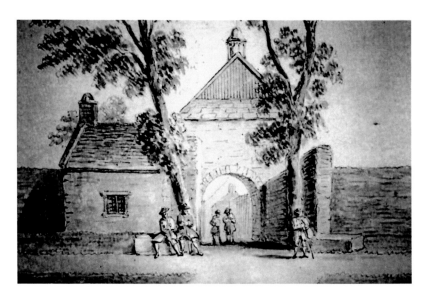

The Gateway, Sherburn Hospital

This is based on an original drawing after S. H. Grimm (1777-84). The gateway was restored and altered about 1896, and its fourteenth-century vaulted arch was, thankfully, kept. This area was where poor travellers would call to be given food, a tradition that continued well into the eighteenth century.

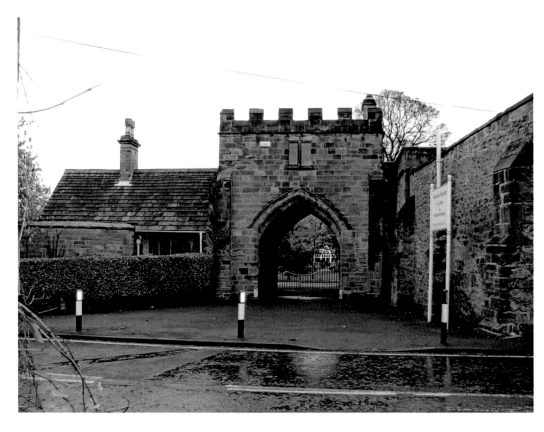

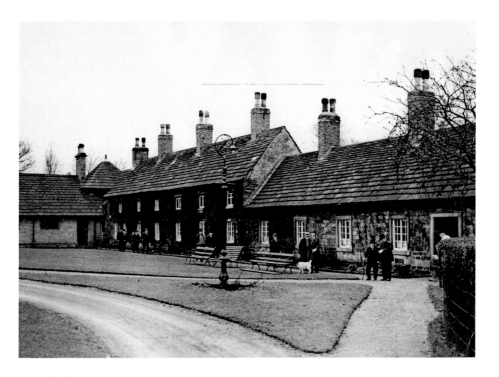

The Almshouses

Grade II listed, the almshouses belonging to Sherburn Hospital are pictured in the 1930s. The living-quarters were built 1760 for thirteen poor and aged brothers, who were known as the brethren. The hospital was originally founded and endowed by Bishop Hugh of Le Puiset, *c.* 1183 (G. V. Scammell), for the reception of sixty-five poor lepers.

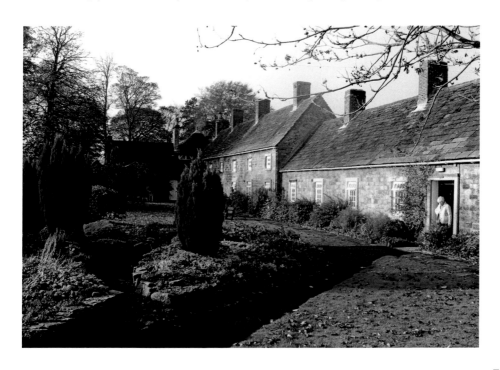

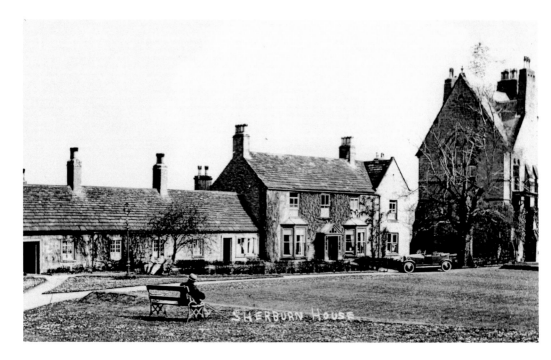

Sherburn Hospital, 1920s

The cottages on the left are the almshouses, now called Thornley House after the hospital's long connection with the manor of Thornley. The property with the bay windows is Shincliffe House (built *c.* 1832); it was once the doctor's residence and is now the home of the present chaplain. On the far right is part of the main hospital building of 1868, now named Beddel House, which was designed by Austin and Johnson.

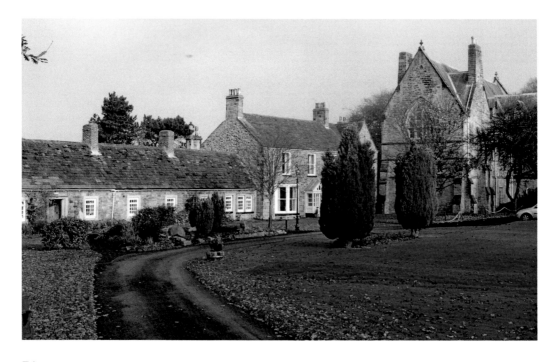

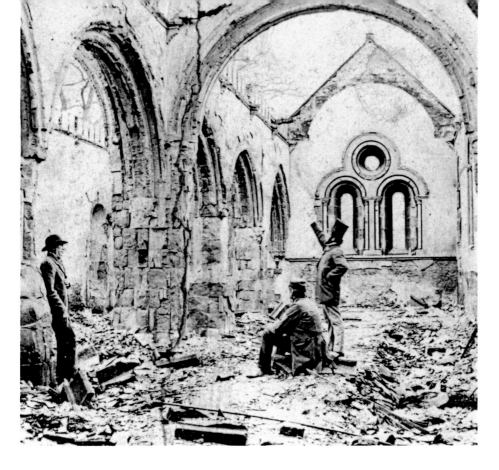

Sherburn Hospital Chapel

The burnt-out ruins of the twelfth-
century Sherburn Hospital chapel,
December 1864. It was first damaged
by fire in 1850 and again in 1859,
after which it was restored by Austin
of Newcastle. Four years after a third
fire, in 1864, it was restored by Austin
and Johnson (see *The Durham County
Advertiser*, 9 December 1864). In the
chapel lie the remains of Thomas Leaver,
preacher to King Edward VI, later
master of this hospital from 1562 until
his death in 1577. His memorial brass
still survives in the sanctuary floor.

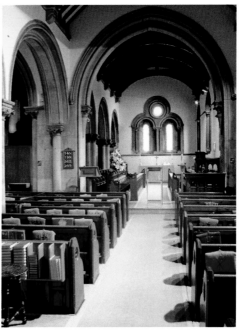

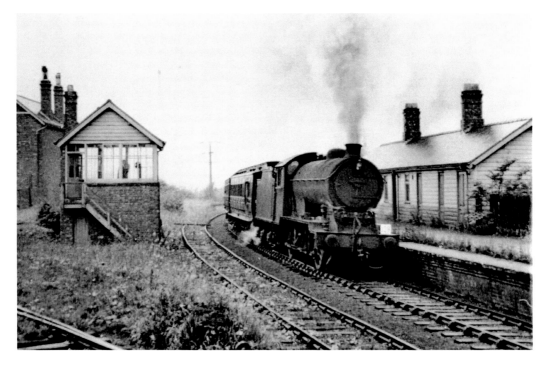

Durham Miners' Gala

A Durham Miners' Gala special train from Elvet Station passing through Sherburn House Station, late 1940s. This station had closed for passenger traffic at the same time as Elvet, in 1931. An exemption was made for the Durham Miners' Gala, and this privilege continued until 1953. Only the station master's house (on the extreme left) survives and is now a private residence.

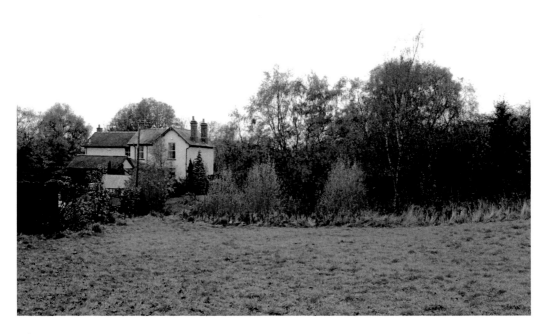

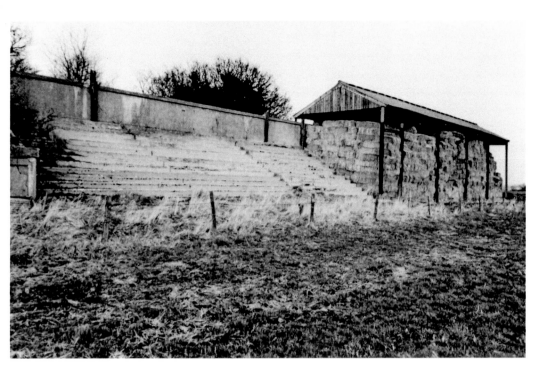

The Grandstand, High Shincliffe Racecourse, 1970s
The horse races had been established by the North Durham and Shincliffe Steeplechase and had opened on 15 May 1895. Its end came prior to the First World War in 1914, when it closed. The stand was demolished after a fire, about ten years ago, after being used for storage by the farmer.

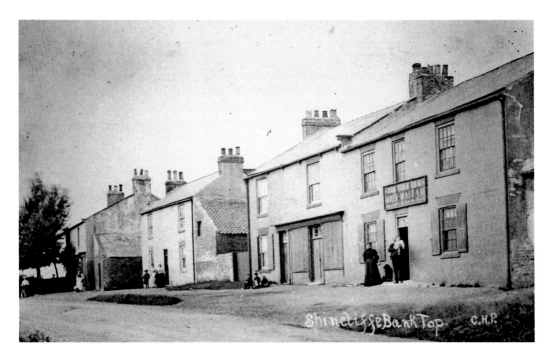

The Oak Tree Inn, Bank Top, High Shincliffe, *c.* 1900
It is now a private dwelling. About this time, Bank Top consisted of dilapidated colliery rows belonging to the former Shincliffe Colliery (1839-1875). Sixty-four of these cottages were purchased from Mr J. A. Love, the colliery owner, and were converted between 1901-03 to become the first aged miners' homes in the area.

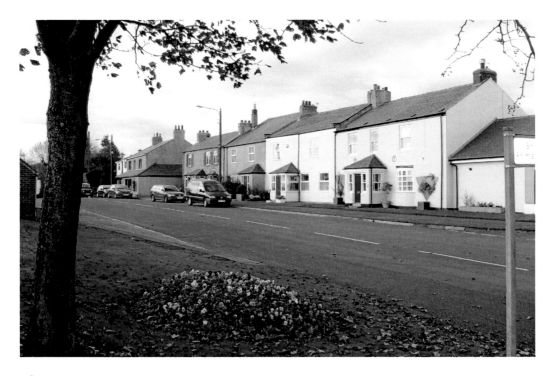

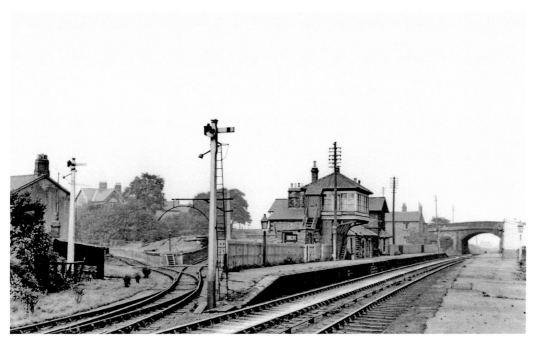

Shincliffe Railway Station from the South, High Shincliffe
Shown here on 14 October 1951, the station was built in 1844 and was designed by G. T. Andrews.
It continued in use until 1941 when it was closed to passenger traffic. For many years it was a
popular restaurant, and it is now a private dwelling reached from the Bowburn Road (see bridge
on the right).

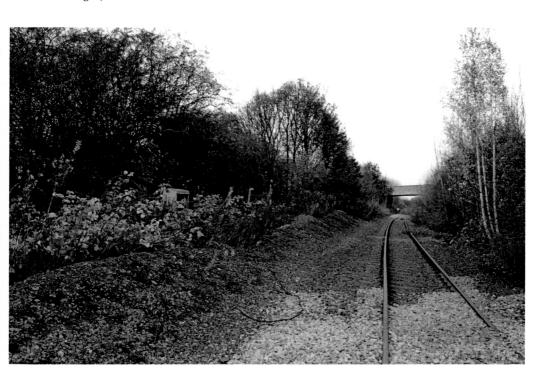

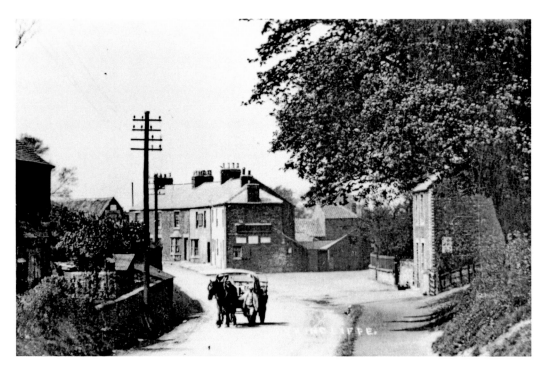

Shincliffe Village viewed from the High Shincliffe Road, 1920s
The central building is the Seven Stars public house. The photograph was taken before the leafy rural Back Lane (on the right) was developed to become the village bypass in about 1934. A local fruit and vegetable seller, with his horse and cart, begins the steep journey to Bank Top.

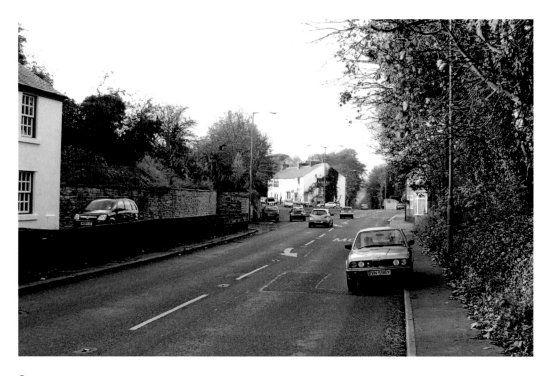

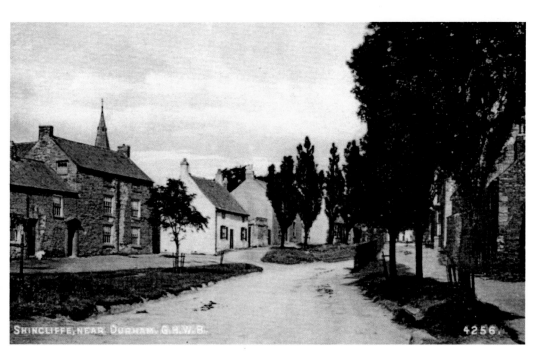

The Village Green Area of Shincliffe, 1900s

Above the rooftop on the left is the spire of St Mary's church. The tallest building, which dates from the late seventeenth to the early eighteenth centuries, is now called The Old House; it has blocked-up windows on the top floor. The whitewashed property, centre, is called The Cottage. The trees in the old photograph were planted by a committee formed by the local vicar, the Revd Arthur Watts, in the 1880s.

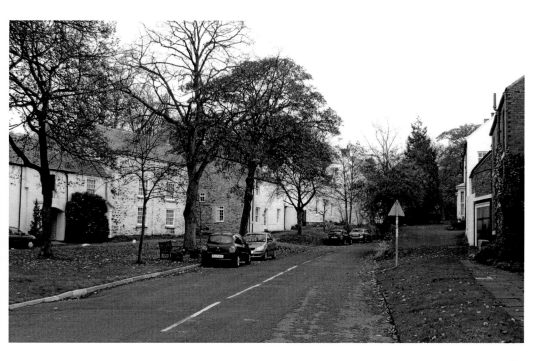

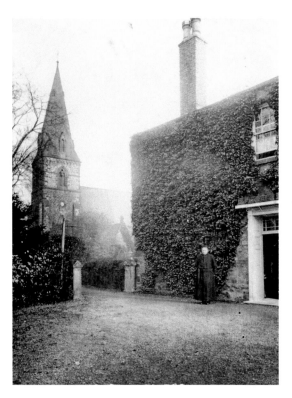

The Rectory and Church,
Shincliffe, 1920s
Built in 1828, the first congregation of
1826 was led by the Revd Isaac Todd.
The services were held in the old
tithe barn, which had been cheaply
converted into a chapel to seat 150
(consecrated 24 September 1826). The
spire was added to the present church
in 1871, designed by architects Walton
and Robson as a testimonial to the
Revd Isaac Todd; it was paid for by
parishioners and friends.

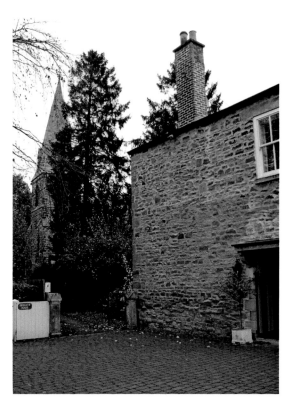

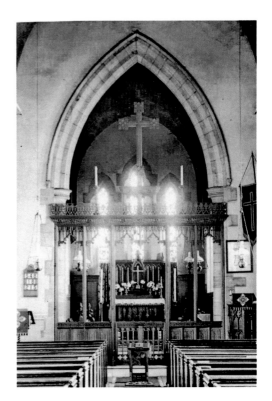

St Mary's Church, Shincliffe
Looking towards the chancel from the nave, St Mary's Church, Shincliffe, 1900s. It was built 1850-51 and designed by George Pickering in the early English style, at a cost of £1,600. The church was consecrated 9 March 1851 by The Rt. Revd Edward Maltby, Bishop of Durham.

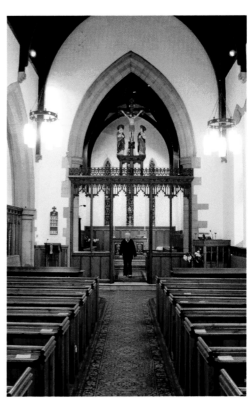

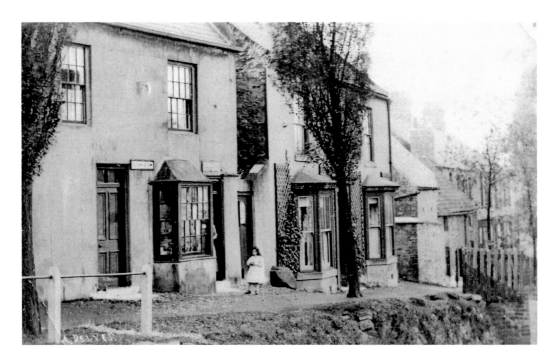

The Post Office, Shincliffe, 1900s (taken by A. Delves of Gilesgate)
The large stone, right of the door, was probably used as a mounting-block for horse-riders.
The building is now a private house called The Old Post Office.

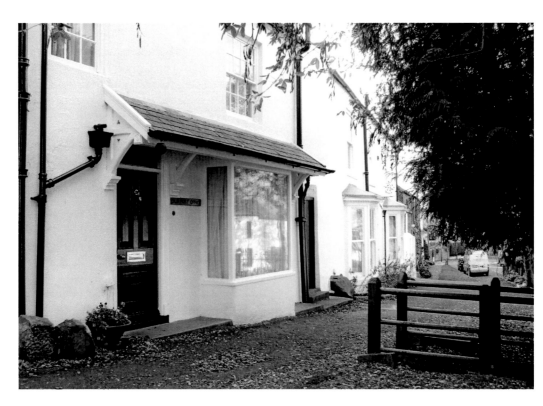

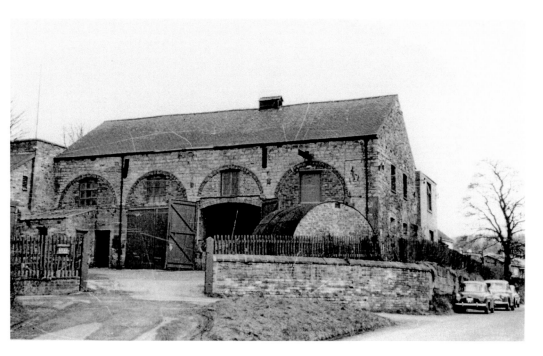

The Old Engine-Sheds, Shincliffe, 1960s (taken by Ken Hoole)
This was the first station to provide a service close to Durham City. It was opened 28 June 1839 and closed in 1893. For many years, the building was used by Durham County Council as a storage area. The sheds are now converted into private dwellings called The Mews.

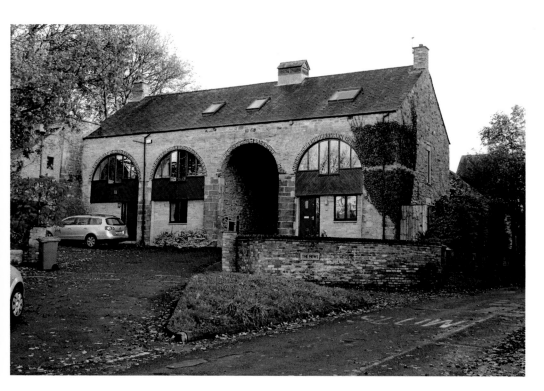

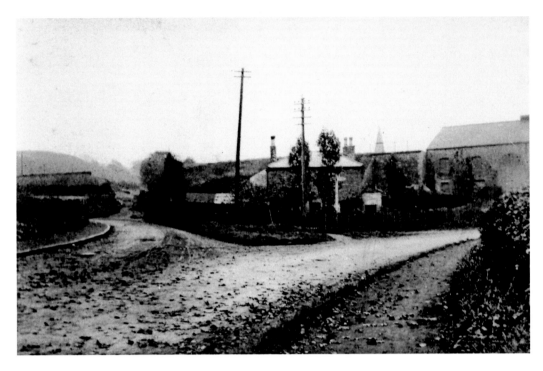

Shincliffe, from near the Rose Tree Public House, c. 1905
The spire of St Mary's church peers above the railway embankment from the old Shincliffe Station.
The road on the left leads to Mill Lane and Sherburn Hospital, which, on the right, goes through
the village. The Back Lane, the opening, left of the central building, became the bypass c. 1934.

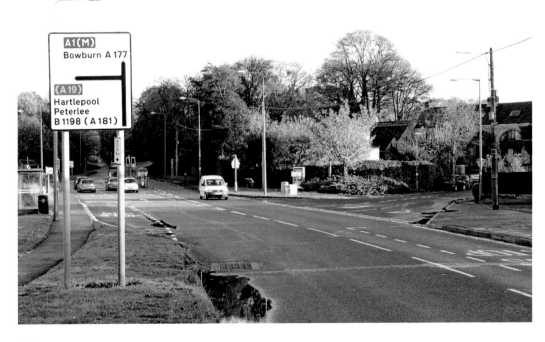

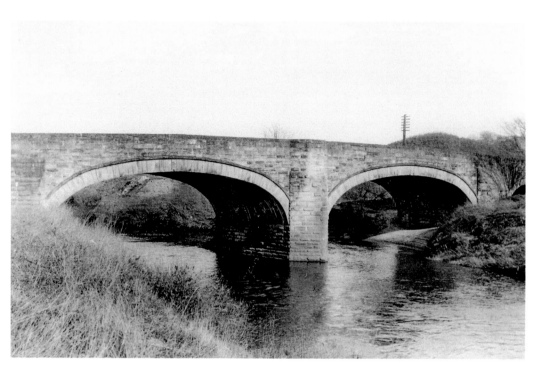

Shincliffe Bridge
The Grade II listed Shincliffe Bridge from the south, 1930s, taken by Joe Robinson. It was designed by Durham architect Ignatius Bonomi c. 1826. The bridge was slightly altered in about the 1960s, when a footpath was attached to the south side.

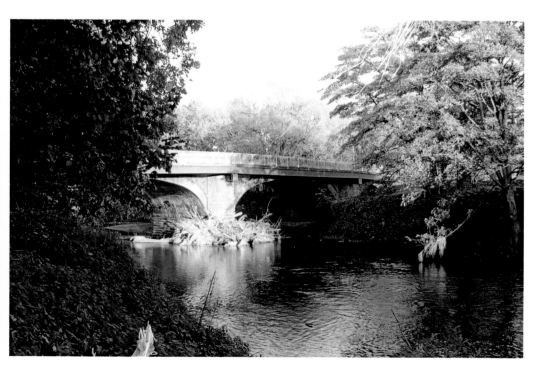

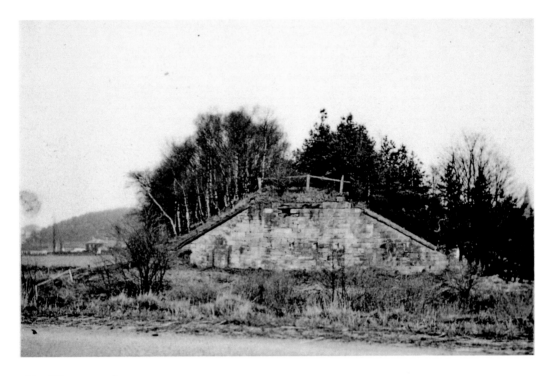

Shincliffe Stone Abutment
The remains of the stone abutment on the Shincliffe side of the river, viewed from Houghall, 1930s, taken by Joe Robinson. It supported a wooden railway bridge that carried coal over the river from Croxdale and Houghall pits. The railway embankment is still clearly visible today.

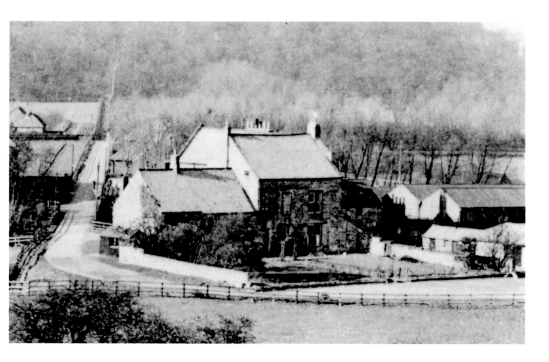

Houghall Manor House, 1950s

Originally a sixteenth- to seventeenth-century moated manor house. Although much altered, it still contained many interesting features, including a secret priest's hole in the main chimney, a fine Tudor fireplace and a Jacobean well-staircase. Once the property of the Dean and Chapter, it was tenanted in the 1860s by Sir Arthur Hazelrig, the Parliamentarian. It is said that Oliver Cromwell once slept here while passing through Durham. Sadly, it was demolished about 1962.

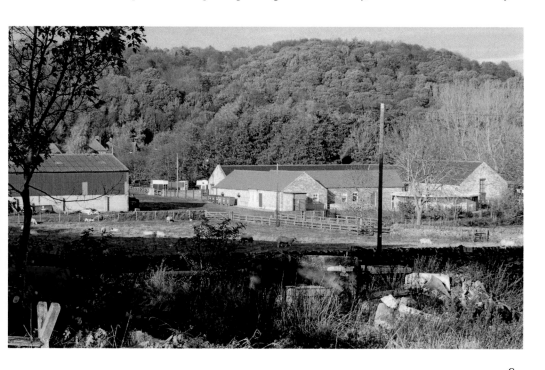

Old Durham Sand Quarry, 1930s
It was reclaimed in the 1970s and has now reverted back to pasture fields. Here, in 1940, the remains of a Roman bath-house (then the most northerly example of a Romano-British farmstead) were discovered by Mr Jack Hay of Gilesgate, while out walking his dogs. Regrettably, the whole archaeological site was destroyed by extensive quarrying during the Second World War.

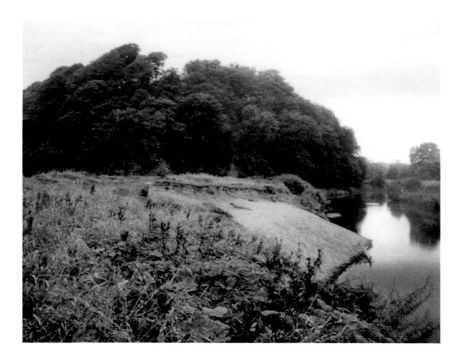

Maiden Castle

'Sandiego' as it was locally known, and the tree covered hill of Maiden Castle, an Iron Age fort, *c.* 1969. The sand bank, on the left, was once a popular swimming place, well-used from the 1930s to the 1970s by boys from the Elvet and Gilesgate areas. A footbridge now spans the river nearby, built in 1972 by the university at a cost of about £20,000 and designed by Ove Arup.

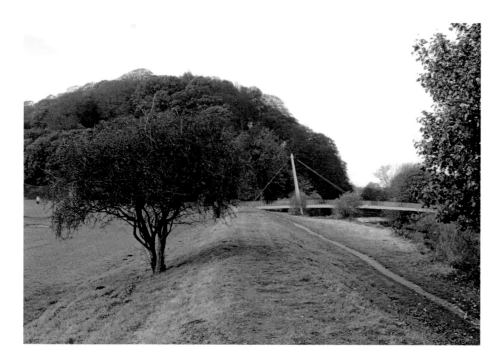

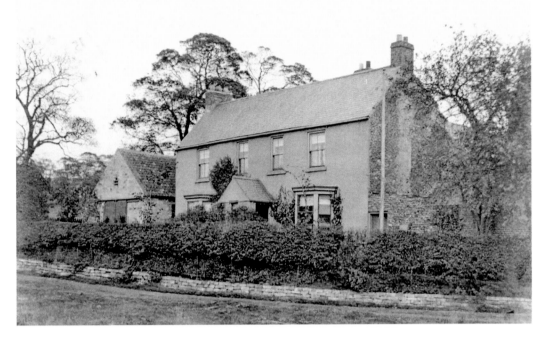

Old Durham Farmhouse, c. 1904

The postcard had been sent to Beatie Hopps at Old Durham Farm. The house is now a private dwelling; most of the former barns have now been converted into homes. The land is still worked by a member of the family, Richard Hopps operating from Manor Farm, High Shincliffe.

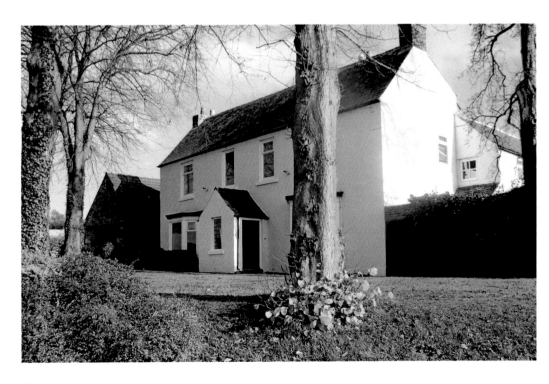

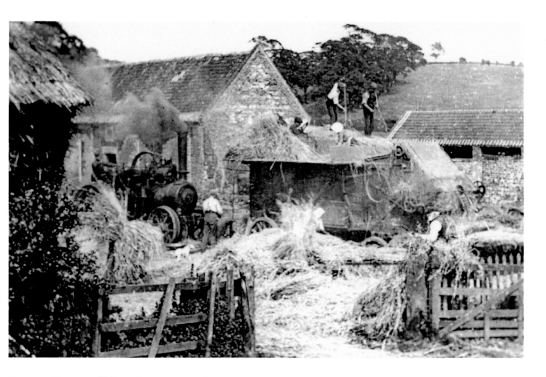

Harvest Time at Old Durham Farm, 1890s

The man with the beard, on the right, was the farmer, Richard Henry Hopps. It was then a common sight to see children helping out on top of the threshing machine (long before the days of Health and Safety). Near the wheel of the steam traction-engine a Jack Russell terrier stands ready on ratting duty.

Taken from *The Victoria County History of Durham*, 1928.

HETTON LE HOLE

Car Ho.

STA.

Murton

461 Inn 429

Middle Rainton 335

Inn

Coll? Little Eppleton

Lyons

420

West Rainton

Colly

Hesledon Moor Ho.

Low Moorsley 486

High 540

Easington Lane

444

Inn

South Hetton

STA.

444

Rainton Gate

301

Elemore Colliery

Hetton le Hill

460

STA. 371

400

Coop Ho.

STA. Pittington

Inn

Elemore Hall

Coldwell Burn

Duncombe Moor

Hall

New Pittington

Colliery 323

Low Haswell 463

425

401

garth 281

257

Elemore Grange

High Haswell

561 Le

464

Holy Cross

401

nside Ho. Ho.

Little Town 400

STA.

Haswell

Inn

Pespool Hall

425

High Lane Ho.

burn

Colliery 309

487

498

Inn 421

Haswell Colliery

465

Inn

Sherburn Hill 500

521

463

489

St Cuthberts Ch.

Ludworth Tower

Ludworth Colliery

Haswell Moor

495 SHOTTON BR.

Inn

lly ers Garth

349

395 Inn

Hare Hill 528

New Shotton

Grange

314

Inn

Shadforth

Running Waters 561

481

Fatclose Ho.

460

Swan Cas. 414

9300 414

Old Cassop 432 500

High Croft Ho. 600

Thornley 584

Inn

Ho.

Colliery

Inn

Inn Colliery

THORN STA.

Wheatley Hill 383

600 Inn

White Ho.

Inn

500 456

Hall 538

Cassop Colliery

600

Thornley Hall

449

Inn 536

481

WELLFIELD JUNC. S.

Old

Inn

Quarrington Hill

Wingate Grange

Durham City Through Time
Michael Richardson

ISBN: 978 1 84868 519 2

£12.99

Durham City From Old Photographs
Michael Richardson

ISBN: 978 1 84868 507 9

£12.99

The Ancient City of Durham
H. T. Gradon, reproduced by Michael Richardson

ISBN: 978 1 84868 516 1

£12.99